POSTCARD HISTORY SERIES

Wilmington

IN VINTAGE POSTCARDS

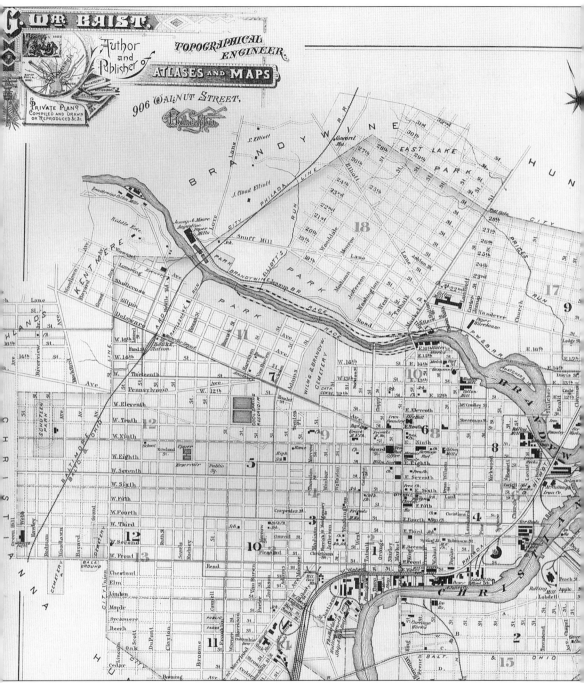

This map published by G.W. Baist in 1887 in his *Atlas of the City of Wilmington, Delaware and Vicinity* shows the city of Wilmington's development along the Christina and Brandywine Rivers. Shipbuilding, the railroad, and heavy industry line the Christina River. Market Street from river to river is the most densely populated area of the city. At the turn of the 20th century, scenes along the rivers and major streets would be depicted on postcards, bringing to life this thriving city. (Courtesy of the Hagley Museum and Library.)

POSTCARD HISTORY SERIES

Wilmington

IN VINTAGE POSTCARDS

Marjorie G. McNinch

ARCADIA
PUBLISHING

ISBN 978-0-7385-0647-0

Published by Arcadia Publishing
Charleston SC, Chicago IL, Portsmouth NH, San Francisco CA

Printed in the United States of America

Library of Congress Catalog Card Number: 00-107237

For all general information contact Arcadia Publishing at:
Telephone 843-853-2070
Fax 843-853-0044
E-Mail sales@arcadiapublishing.com
For customer service and orders:
Toll-Free 1-888-313-2665

Visit us on the Internet at www.arcadiapublishing.com

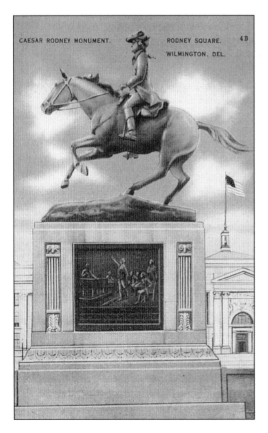

The equestrian statue of Caesar Rodney was placed in a park named in his honor, Rodney Square Park, on July 4, 1923. Rodney rode from Dover to Philadelphia to sign the Declaration of Independence in 1776, casting the deciding vote for Delaware. The square was designated a memorial site to Rodney in 1915, and the equestrian statue was designed by New York sculptor James Edward Kelly. The Gorham Company of Rhode Island cast the statue as well as the two bronze tablets on the pedestal, which depict Thomas McKean greeting Rodney in Philadelphia and Rodney casting the deciding vote for independence. (Author's Collection.)

CONTENTS

ACKNOWLEDGMENTS

This postcard history was an exciting one to compile, but I could not have completed it without the help of many willing and generous people. I would first like to thank Mr. Gordon Pfeiffer, a Wilmington resident who made his extensive postcard collection available for my use. Over 100 of his cards can be seen in this work. Next, I would like to thank my colleagues in the Pictorial Collections Department of the Hagley Museum and Library: Jon Williams, Barbara Hall, Laura Detrick, and Kathleen Buckalew. They found Wilmington postcards in their collections and helped me to do the photographic work. Ellen Rendle at the Historical Society of Delaware assisted me in researching the postcard collection there and did the photographic work for me. The Special Collections staff at the University of Delaware, headed by Timothy Murray and Rebecca Johnson Melvin, were particularly supportive and patient with me by their willingness to share their new postcard collection. Lastly, I extend thanks and love to my family, particularly to my mother, Dorothy Stevenson Gregory, whose memories of the sites in my book made the work a pleasure. A note of explanation: only those views not from Gordon Pfeifer's collection will be identified.

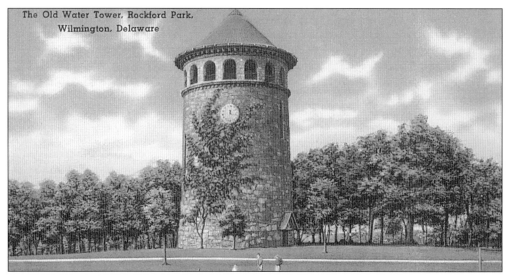

The Old Water Tower, Rockford Park, Wilmington, Delaware

Rodney Square had been the city's first reservoir, and as the city grew to the west, Cool Springs and Eighth Street reservoirs provided the water supply. By 1900 the population stretched to Rockford Park. This park was developed on land donated by Wilmington Park Commissioner William P. Bancroft, in 1895, with the du Pont family also donating acreage at a later time. Water needs for that area were met by the construction of the Rockford Water Tower, built on the highest point in the park in 1901. The tower, with 132 steps that lead 115 feet up to an observatory at the top, has a 500,000-gallon tank and has been a Wilmington landmark for over a century. (Author's Collection.)

INTRODUCTION

Settlements in New Castle County began in the city of Wilmington, Delaware, after Peter Minuit led the Swedish up the Christina River in 1638. Following the Swedes came the Finns, the Dutch, and the English. Wilmington was eventually settled by Quakers, who were encouraged to come to the area because of the William Penn charter and because of its waterways. Families such as the Gilpins, Shipleys, Tatnalls, Canbys, and Leas began enterprises along the Brandywine River that gradually attracted more people and businesses to the area. In 1655, when the Dutch assumed power over the Swedish colony in Wilmington, the Swedish/Finnish population was approximately 1,000; the Dutch sent an additional 900. Two hundred years later, Wilmington had a population of 30,000, and by 1940, Wilmington's population was near 110,000. Wilmington's industry and residential areas grew naturally along its rivers and inland from there. Wilmington's business center in the 1800s remained near the Christina River at Front Street and King's Highway (Market Street). After the Civil War, railroad lines and electric trolleys moved the populace north and west, so that by 1900 Wilmington boasted growing new neighborhoods and stable industry.

Wilmington of the 1880s had grown in population and industries. There were three horse-car lines and a new electric line, 5 steam railroads, 33 hotels, 9 newspapers, 2 theaters, 56 organized religious associations, and real estate valued at over $38 million. New industries located along the Christina River and by the Philadelphia, Washington & Baltimore Railroad included foundries, shipbuilding, railroad car and carriage buildings, and leather factories. Needless to say, industry and business in the city by 1900 was varied and changed the city's landscape. The explosives industry operated by E.I. du Pont de Nemours & Company for nearly 200 years on the Brandywine River, north of Wilmington, was nearly sold to its competitor, Laflin & Rand, when it was purchased by three du Pont cousins, T. Coleman du Pont, Pierre S. du Pont and Alfred I. du Pont, in 1902. These three men alone would significantly change Wilmington's landscape. The headquarters of the DuPont Company was moved to Tenth and Market Streets by 1907 and, by the end of the 1930s, filled in the entire block of Tenth, Eleventh, Market, and Orange Streets, adding a hotel and playhouse to Wilmington's downtown. P.S. du Pont and his brothers, Lammot and Irenee, instigated the development of Rodney Square Park, including the building of the City/County Building, the Wilmington Institute Free Library, and the Federal Post Office, essentially effecting the move of Wilmington's business center to that area. The Harlan and Hollingsworth shipbuilding industry on the Christina built tourist ships for the Wilson Line based in Wilmington, and the plant was also very active in building naval vessels for the Bethlehem Steel Company during the two World Wars. Banks lined Market Street. They were Delaware Trust, Artisans Savings, Wilmington Savings Fund, and Union National Bank. As Wilmington's business thrived, the civic and social sites kept pace.

Churches, schools, hospitals, and fire companies filled very real needs in a city, which saw an influx of immigrants, who came to the area between 1880 and 1924. These immigrants supplied the labor for the railroad, shipbuilding, and leather industries, and in turn, the city supplied needed social institutions. The religious denominations to become established permanently in Wilmington, by chronological order, were; the Quakers, or Friends; the Episcopalians; the Presbyterians; the Baptists; the Roman Catholics; the Methodist Episcopalians; the Lutherans; the Swedenborgians; and the Unitarians. Most of these

religions provided schools for the young in their congregations, and by 1829, Delaware legislated public money for schools, opening the avenue for public education. Hospitals in Wilmington began to operate as public institutions at the end of the 19th century with the building of the Delaware Hospital and the Homeopathic Hospital (Memorial). Fire companies were numerous in the city and included the Fame, Phoenix, and Independence Fire companies.

Wilmington's need for hotels, restaurants, and entertainment were also being met. The city's number of hotels during the 1880s slowly declined in the mid-20th century because of the growth of the suburbs and because of the decline of heavy industry in the city. One other reason for the decline was the construction of the Hotel du Pont in 1913, which had 150 rooms. The Hotel Darling, Kent Hotel, and the Wilmington Hotel, all near the Hotel du Pont, served the business workforce in the Rodney Square business district. Restaurants along Market Street included those within the hotels such as the Brandywine Room and the Kent Hotel restaurant. As the silent movie gained popularity in 1900, movie theaters, such as the Garrick and the Majestic, began to line Market Street. After interstate I-95 was constructed through the city in 1968, movie theaters began to disappear. Rodney Square is still the business center of Wilmington in the 21st century, with hotels and banks thriving. The record of the city's history is illustrated in the following pages by vintage postcards showing many of the above mentioned sites.

Postcards, illustrated or blank, can be dated back to 1898. Private mailing cards date from 1898 to 1901; those with the undivided back date from 1901 to 1907; those with the divided back date from 1907 to 1915; cards with the white border date back between 1915 and 1930; those on linen date from 1930 to 1944, and photo-chrome postcards date from 1945 to the present. Two publishers of the Wilmington postcards seen here are George A. Wolf and E.R.S. Butler and Sons. Postcards can be either photo cards or hand-painted illustrations. Whichever they are, they gave a picture of the city to the recipient and survived to tell Wilmington's history here.

One

DOWNTOWN WILMINGTON

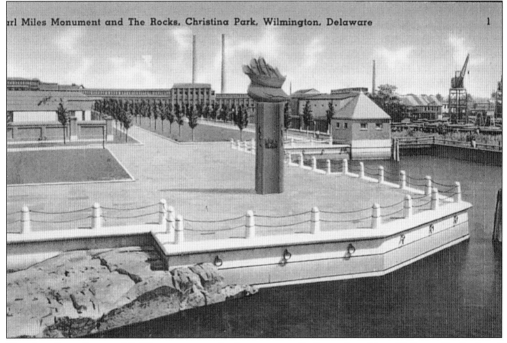

rl Miles Monument and The Rocks, Christina Park, Wilmington, Delaware 1

The Swedes, along with Finns among their group, sailed on the ships *Kalmar Nyckal* and *Fogel Grip* to North America in 1638. They navigated the Delaware River and traveled up the Christina River, where they landed at a point called "The Rocks" on March 29th of that year. They built Fort Christina and settled on the site, exercising control of the river until the Dutch seized the fort in 1655. The Swedes and Finns remained, however, establishing themselves as Wilmington's first permanent settlers. This view shows the monument to the Swedes by Carl Miles at The Rocks in Fort Christina Park. (Courtesy of the Historical Society of Delaware.)

The Christina River is one of two tributaries that branches off the Delaware River at Wilmington. The Brandywine River, the other tributary, flows northwest and its shores became the site of many milling establishments. The Christina River flows southwest and its shores became the site of heavy industry, such as shipbuilding, railroad car building, and leather making. Since the main mode of transportation of goods or raw materials to the millers on the Brandywine in the early 1800s was by boat, merchants and farmers from southern New Castle County would come up the Christina. By the 1900s the Christina had become a leisure spot. (Author's Collection.)

Following the Swedes were the British, German, and French, who arrived in Wilmington in the 17th and 18th centuries and settled along the Brandywine and Christina Rivers inward. Log and wood houses gave way to homes of stone and brick, and the settlement was formed in a grid pattern. The Quakers were quick to establish mills and merchant routes on the rivers, and their estates included open land to farm. By 1814, paper, flour, grist, and sawmills peppered the shores of the Brandywine, with 14 gristmills alone.

The old town hall, which in the 20th century became the headquarters of the Historical Society of Delaware, was alleged to have been designed and constructed by French émigré Peter Bauduy in 1791. At a town meeting there on February 10, 1832, the citizens of Wilmington adopted the city charter granted by the General Assembly of the State of Delaware. The old government, ruled by a burgess, was changed to a mayor-council type. The 12 council members were elected for a term of three years. The mayor served a three-year term, the alderman served for five years, and the treasurer and assessor were elected annually.

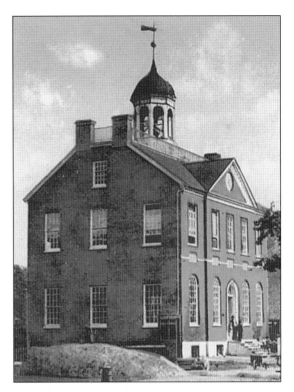

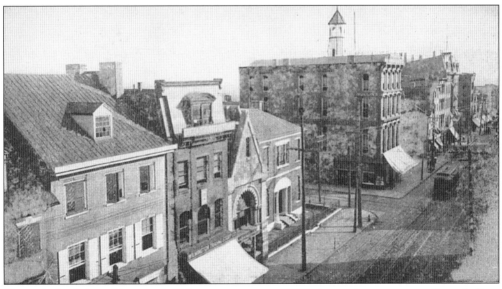

The spiral of the old town hall became a part of Wilmington's ever expanding skyline, as seen in this image looking south from Sixth Street. By the 1830s, manufacturing was replacing milling, meaning that industry was spreading along the Christina river front, and city residents were moving north of Fourth Street along Market Street and east toward King Street. Buildings below Fourth Street were converted to commercial use, with the first floor used as a storefront and the second floor used for manufacturing. (Courtesy of the Hagley Museum and Library.)

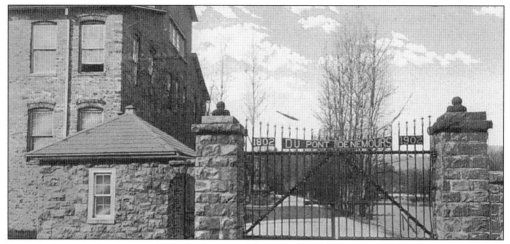

French émigré Eleuthère Irénée du Pont, with the help of his countryman and Wilmington resident Peter Bauduy, founded the Du Pont Gunpowder Works on the Brandywine River, north of Wilmington, in 1802, selling his first manufactured powder in May 1804. E.I. du Pont's gunpowder business became a major explosives works in the North and produced half of the ammunition used by the North in the Civil War. By the turn of the 20th century, the E.I. du Pont de Nemours & Company began manufacturing in product lines other than explosives, although the firm provided much-needed explosives in World War I. The powder yards along the Brandywine closed in 1921.

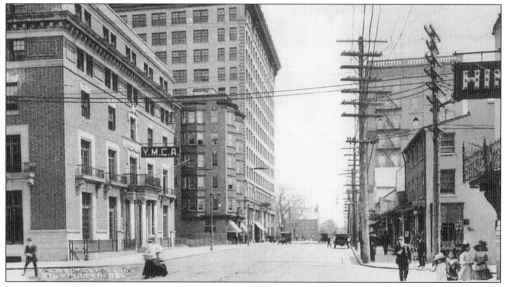

Cousins T. Coleman du Pont, Pierre S. du Pont, and Alfred I. du Pont rescued the DuPont Company from sale in 1902. The company's workforce had expanded away from the Brandywine, and company administrative and sales personnel were housed in numerous buildings along Market Street. The cousins moved the company headquarters to Market Street at Tenth Street, having its first section completed by 1907, and its second and third sections finished by 1913, featuring a hotel and theater. These three sections fronted along Market between Tenth and Eleventh Streets and would soon fill in the block fronting on Orange Streets. (Courtesy of the Hagley Museum and Library.)

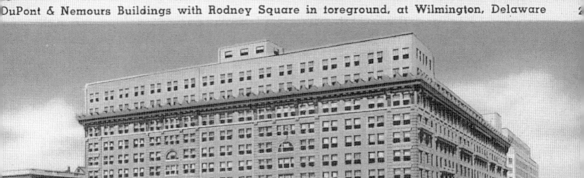

The DuPont Building rounded out the block of Tenth, Eleventh, Market, and Orange Streets by 1931. In 1916, section four was built to front on Tenth Street just behind the first section. The Young Men's Christian Association building was razed to make room. The fifth section of the building, with frontage on Eleventh and Orange Streets, was completed in 1919. The Gold Ballroom was part of this section. Finally, in 1931, the company added a sixth section, which closed the structure on the Tenth and Orange Street side. The total amount invested in the Du Pont Building by this time was $7.6 million. The total square footage of the building as it stood in 1919 amounted to 13.5 acres. This view shows the sister building, the Nemours Building, built in the late 1930s with an enclosed bridge connecting the building. The DuPont Company sold the Nemours Building in 1999. (Author's Collection.)

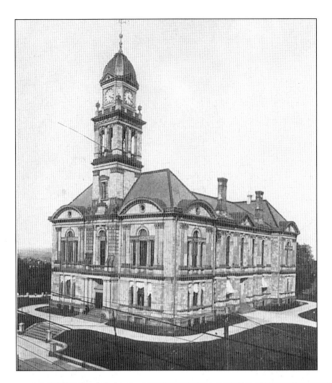

The New Castle County Courthouse was built in 1881 fronting on Market Street between Tenth and Eleventh Streets on the site of the old Wilmington reservoir, which was drained in 1878. The location was known as the Courthouse Square. The building was constructed of Brandywine granite trimmed with brown, buff, and green serpentine stone. The county vacated this courthouse in 1917, and for the duration of World War I, it provided offices for the Registration Board, the Du Pont Engineering Company, and the Ordnance Department. It was demolished in 1919. (Courtesy of the Hagley Museum and Library.)

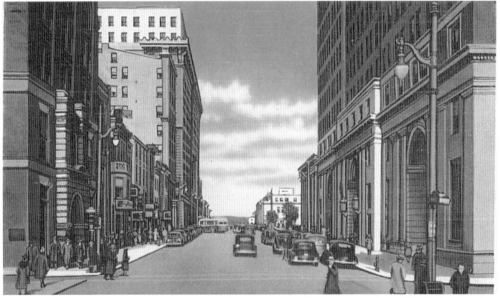

This view from Market Street looking north towards Rodney Square from Ninth Street after World War II shows a downtown business center full of activity. At Ninth Street two banks face each other, the Delaware Trust Bank and the Equitable Trust. Rodney Square is seen in the distance with the Wilmington Institute Free Library behind the Delaware Trust Building, the Federal Building facing the library on the Square, and the Du Pont Building on the west facing Market Street. Cars line the streets and the city bus is making its rounds. It is a view of a city still evolving. (Author's Collection.)

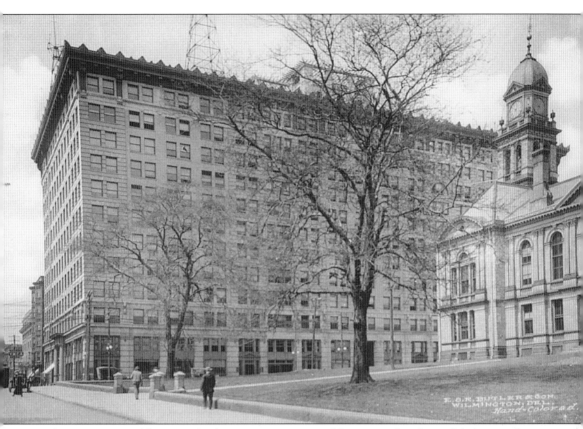

The Du Pont Building was built in six sections, and by 1915, the date of this view, three sections had been built, all fronting Market Street between Tenth and Eleventh Streets. The Manufacturers Contracting Company built the first section, completed in 1907. It was a 12-story-and-a-basement, fireproof office building, the first four floors being of Indiana limestone. The rest of the building had blue stone trimmings, copper cornices, and 5-foot-wide windows. The sidewalks were 15 feet wide. The Wilmington Trust Company, a bank incorporated by the du Pont cousins to handle the transactions of the building, was on the first and second floors. The third, fourth, and fifth floors were for general office use, while the Du Pont Company occupied the sixth to the twelfth floors. The second section was completed by 1911 and the third by 1913. Within sections two and three are the 150-bedroom Hotel du Pont and the 1,256-seat playhouse. In 1919 the old county courthouse facing the Du Pont Building was razed, and Rodney Square Park was developed on the site. (Courtesy of the Hagley Museum and Library.)

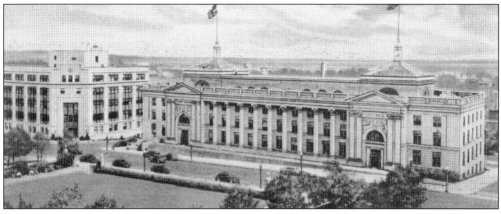

By 1910 the green serpentine building, the New Castle County Courthouse, was experiencing overcrowding. City offices were housed in the old town hall at Fifth and Market Streets, the Eckel Building next door, and wherever space could be found. A joint City/County Building was decided on as the solution by the city and county governments, and it became the second civic structure built on the square. This new structure, costing $1.5 million, was constructed architecturally to conform to the classical design for urban centers promoted at the Columbian World's Fair in 1893, and was completed in 1917. This building, which will be vacated early this century, has served the city for eight decades. (Courtesy of the Hagley Museum and Library.)

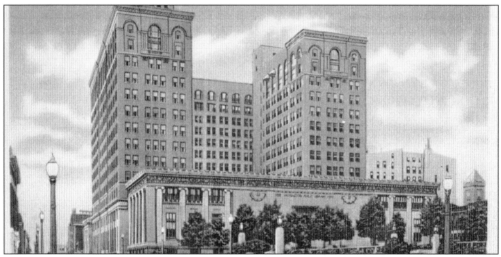

The Wilmington Institute Free Library was the third structure built on Rodney Square Park, following the classical architectural design of the Du Pont Building and the City/County Building. The institute was housed on the second floor of a building on the corner of Fifth and Market Streets and was badly in need of a new home. Pierre S. du Pont, president of the Du Pont Company during World War I, was instrumental in moving the library to a new building on the square. He negotiated with the First Presbyterian Church for the land at Tenth Street between Market and King Streets and donated the acreage to the city for the library. The remains in the Presbyterian cemetery were reinterred in the Wilmington and Brandywine Cemetery nearby. The Wilmington Institute Free Library opened in 1923, and has served as the city's library into the 21st century. (Courtesy of the Hagley Museum and Library.)

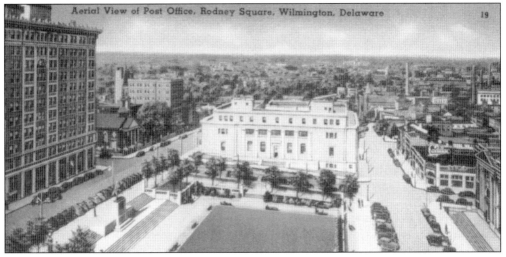

The idea of developing the square into a park began in the spring of 1915 once construction of the City/County Building was underway. Many of the city's civic-minded businessmen became involved. William P. Bancroft, president of the Board of Park Commissioners, headed an executive committee that worked with a council of members of the Historical Society of Delaware. The square was designated a memorial site for Caesar Rodney. The Philadelphia architectural firm of Zantzinger, Borie, and Medary, who completed the job in 1921, developed Rodney Square Park. The library construction and the creation of the equestrian statue, both started about the same time as the park, would take two more years to complete. The area surrounding Rodney Square Park had taken on a definite shape and had established its role as the civic center of Wilmington. (Courtesy of the Historical Society of Delaware.)

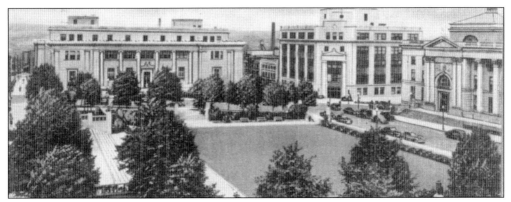

The new Federal Building filled in the fourth side of Rodney Square Park in 1937. The block bounded by Eleventh, Twelfth, Market, and King Streets was the McComb-Winchester estate, which was sold to the federal government for $500,000. The Philadelphia firm of Irwin and Leighton was awarded the contract, and an average of 200 local men were employed nearly every day for the length of the project. Construction began in September 1935 and the building opened January 25, 1937. The Federal Building housed the post office, customs house, and Federal courts. Its opening marked the completion of Rodney Square as the commercial and civic center of Wilmington. Continental Life Insurance eventually replaced the Cadillac dealership in between the City/County Building and the Federal Building. (Courtesy of the Hagley Museum and Library.)

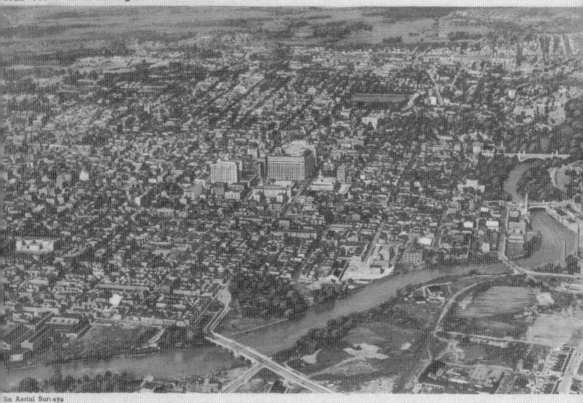

lin Aerial Surveys

Rodney Square Park is visible at the center of this aerial view of Wilmington from the 1950s. The DuPont Building, the Delaware Trust Building (to the left), and the City/County Building are prominent structures in this skyline, emphasizing the spread of the city away from the center. Wilmington of the 1950s had a population of over 110,000, but by the 1980s, it had declined to 70,000. The Brandywine River (to the right) boasts five bridges as the river flows to join the Christina and Delaware Rivers. The following postcard views are street scenes and neighborhoods within this big picture. (Author's Collection.)

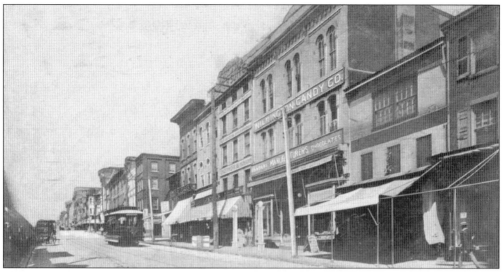

The development of Wilmington up from the Christina River began at Front Street and up Market Street. By 1860 water transportation had given way to rail transportation with the construction of the Philadelphia, Wilmington, and Baltimore Railroad station at Front and French Streets. Joshua T. Heald, creator of the Board of Trade and a real estate developer, formed the Wilmington City Railway Company in 1860. Envisioning the city as an East Coast port and rail center, he laid track from the station up Market to Tenth Street. The horse cars began rolling in 1864, and gave way to electric trolleys in the 1890s.

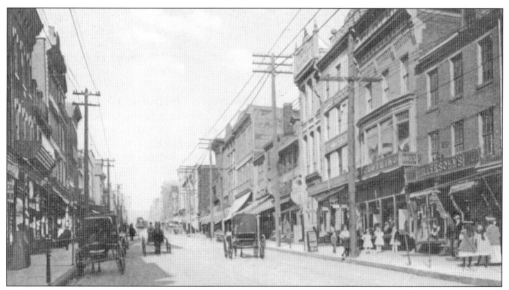

This view of Market Street taken from Second Street looking north around 1910 shows the trolley tracks with horse-drawn carriages riding over them. Storefronts dotted this area of the city early in the 19th century, and new residents moved their homes north of Fourth on Market Street. As the population grew, stores along Market Street, even above Fourth, grew to keep pace with demand. People bargained for their goods, bought in bulk, and carried their goods home well into the 1890s. Maximillian Lichtenstein had a variety store at 226 Market Street in the 1850s, which served this public.

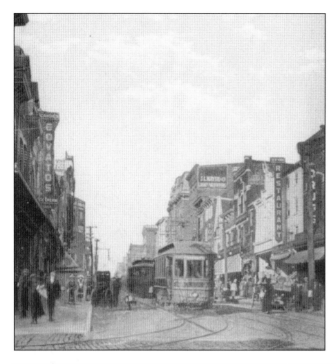

As Wilmington moved into the 20th century, Market Street became a street of shops, markets, and restaurants. Store owners and their workers lived away from their work, for the most part, by the time the DuPont Building scraped the sky in 1907, thanks again to Mr. Heald, who developed residential areas along Delaware Avenue and in south Wilmington. The electric trolley riding over cobblestone streets took workers and shoppers alike downtown. The Govatos family store can be seen on the left.

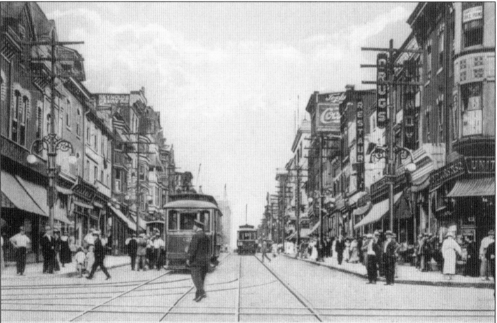

This view of Fourth Street looking north up Market presents a city full of business activity. Fourth Street defined the cutoff point between the manufacturing district to the south towards the Christina River, and the retail and banking district between Fourth and Sixth Streets. Along with the buildings, the street trolleys electrified, and an energy penetrated Wilmington to grow and prosper. The people themselves were now able to purchase ready-to-wear clothes, and to have their purchases delivered to their homes. It was a new century.

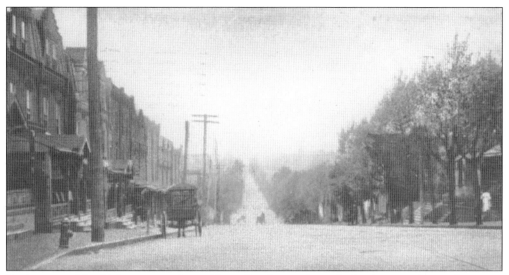

By the turn of the 20th century, city residents lived away from the business and manufacturing districts along Front Street and up Market Street. Joshua T. Heald had constructed row house dwellings in areas around the city, similar to this section looking north on Fourth Street from Washington Street. Between 1880 and 1924, over 27 million immigrants entered the United States from Italy and Eastern Europe, and Wilmington became a permanent home for many. Row houses provided much needed shelter for an expanding city population.

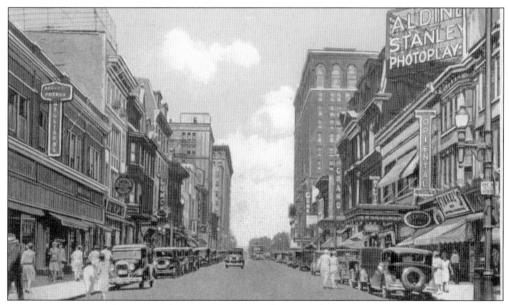

Continuing up Market Street from Sixth Street, the city of the 1920s boasts taller buildings, some skyscrapers, to house the ever-growing downtown businesses and industrial community, which had clustered along the electric trolley line along Market Street. The trolley, still the favorite mode of travel downtown, was competing with the automobile. There were numerous dry goods and variety stores, and men's clothing stores outnumbered the women's because of the predominance of men in the workforce.

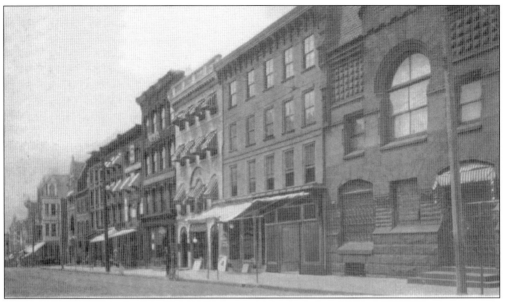

Market Street between Fifth and Sixth Streets was home to two movie theaters—the Savoy, which opened in 1907 as the Nickelodeon and closed in 1967 as the Towne, and the Arcadia, next to the old town hall. Woolworth's five-and-dime store also stood on this block, as did the Artisans Savings Bank, which still operates today. The Historical Society of Delaware now has its museum and library on this block.

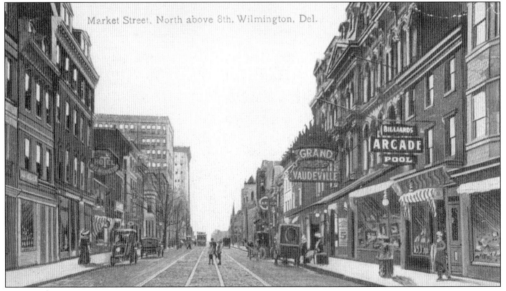

Looking north above Eighth on Market Street, a sign for the Grand Opera House announcing vaudeville is seen mid-block. The Grand Opera House was a cast-iron façade structure built by the Masons in 1871, and was the first theater in Wilmington for live performances, musicals, and drama. In the 20th century it became a vaudeville house and second-rate movie theater and was near ruin when it was revived in 1976 to become the Grand of former days. The Hotel Wilmington was across the street, and the DuPont Building can be seen in the distance.

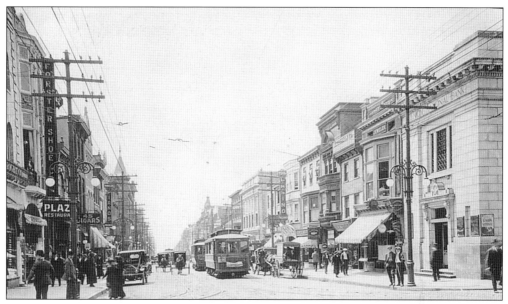

Market Street, south of Eighth Street, shows the Union Bank on the corner with D.C. Jones and later Edith McConnell's catering business next door. Retail and banking had moved up from Fourth to Sixth Streets, as the shoe store on the left attests. This 1915 view would change drastically by the 1950s, and Woolworth's would sit at Ninth and Market Streets. (Courtesy of the Hagley Museum and Library.)

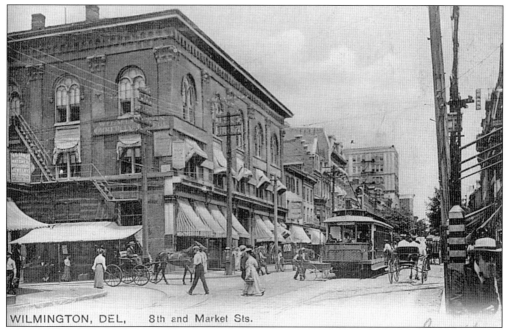

WILMINGTON, DEL, 8th and Market Sts.

Yet another view of Eighth and Market Streets shows the site of what was Goldey College on the corner. It was housed on the second floor and was cramped and hazardous. By 1923, it moved to Ninth and Tattnall Streets. The Ford Building can be seen in the distance on the corner of Tenth and Market Streets. The DuPont Building had not yet been built.

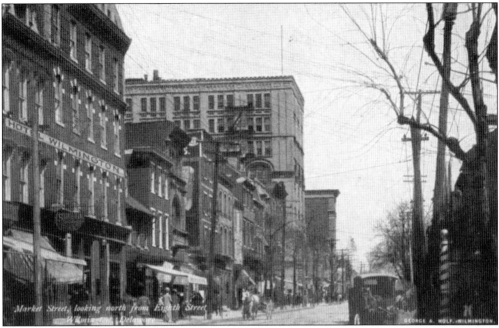

Moving up Market Street between Eighth and Ninth Streets, the Hotel Wilmington and the Equitable Trust Building can be seen. The bank building was one of 14 buildings that housed employees for the DuPont Company before its headquarters relieved the space crunch in 1907. The Hotel Du Pont eclipsed the Hotel Wilmington after it opened in 1913.

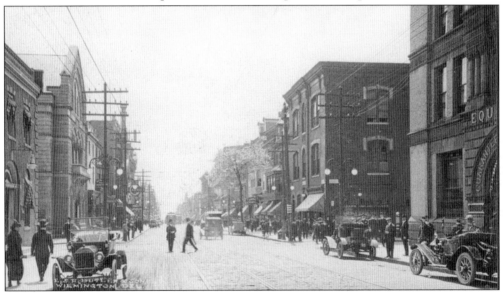

At Ninth and Market Streets looking south, fancy roadsters line the street. By 1915 numerous banks had moved north. The Wilmington Savings Bank, next to the Garrick Theater and up from the Grand, is on the left, and the Equitable Trust is on the opposite corner. The stores lining Market Street had awnings in the summertime, as did the rooms of the Hotel Du Pont, until cigar ashes from above sent some up in flames. (Courtesy of the Hagley Museum and Library.)

Market Street above Ninth Street shows the familiar outline of the DuPont Building with a trolley car headed in its direction. The trolley lines turned left at Tenth Street and ran out Delaware Avenue. On the right are the spirals of the old Presbyterian Church, which was razed to make way for the library and Alfred I. du Pont's Delaware Trust Building.

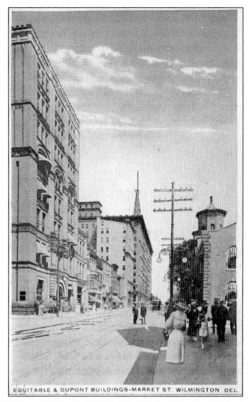

EQUITABLE & DUPONT BUILDINGS-MARKET ST. WILMINGTON DEL.

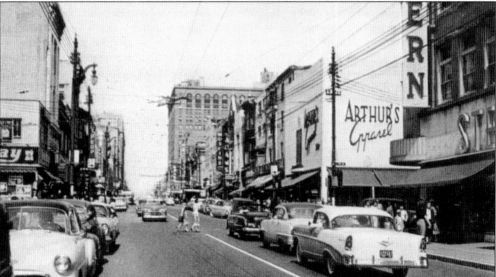

The look of Market Street had certainly changed by 1960. The architecture of the stores and buildings was more streamlined and less brick was being used. One such example was Arthur's, which opened as the only women's furnishings store in 1924 at 700–702 Market. The cars lining the streets showed the prosperity of the times, with the different models in multiple colors. The electric light fixtures appear to be the only throwback to the 1920s. (Courtesy of the University of Delaware Special Collections.)

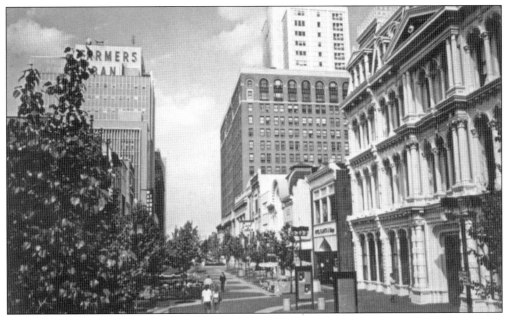

Market Street of the late 1970s between Eighth and Ninth Streets is still the locale for banks, with the Bank of Delaware, the Farmers Bank, and the Delaware Trust all visible. The Grand underwent restoration in 1976; not only to its cast-iron façade, but with live performances that made it once again a cultural center. (Courtesy of the University of Delaware Special Collections.)

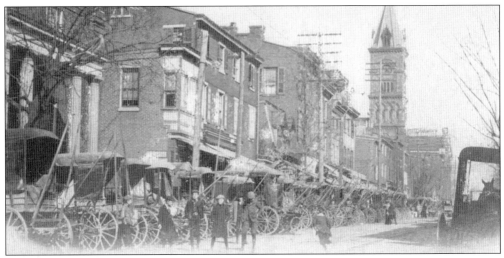

Throughout Wilmington's history, street markets abounded along Market Street, and market houses were built. When the trolley track was laid up Market Street in 1863, the street markets moved to King Street, where it became fully entrenched by 1872. The farmers could park their conveyances, such as carts, Dearborns, or market wagons, with their tailboard to the pavement, and display their wares on benches placed along the curb. Items for sale included butter, milk, eggs, sausage, scrapple, vegetables, and poultry—all fresh from the farm. The fish market was below Second Street on King Street. (Courtesy of the Hagley Museum and Library.)

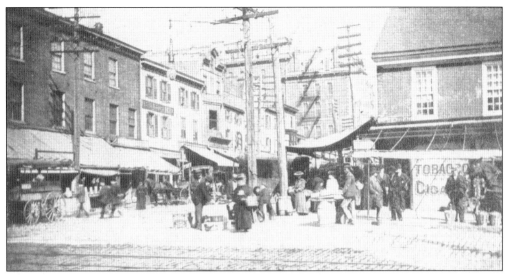

By 1900 the city's population had grown to 76,000. Even though packaged goods and ready-to-wear clothing were being sold, the street vendor still held sway in the city. Market days before 1890 used to be on Saturday and Wednesday, but because of continued growth in the city and also because people from across the Delaware River brought their goods to sell, market days began to include Tuesday and Friday as well. By 1900, Fourth Street between Market and Walnut Streets had become a food marketing center, with 26 stores clustered in those few blocks.

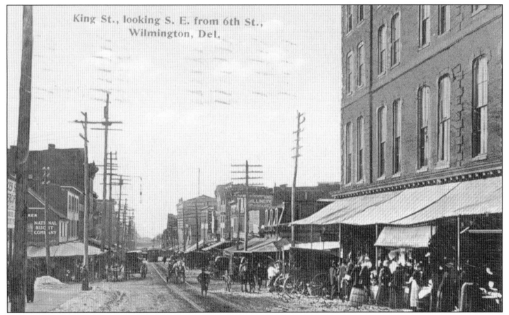

King Street had become a mix of retail and business by the 1880s. Approximately 120 stores, businesses, professional offices, and small industrial or craft shops lined King Street from Front Street up to Ninth Street. One could find a little bit of everything including millinery, household goods, and services. On market days, King Street would fill sometimes with 200 to 300 farmers, all ready to bargain.

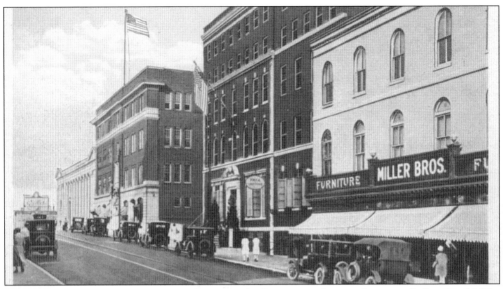

King Street between Ninth and Tenth Streets had grown rather sophisticated after World War II, when compared to the street markets of the early 1900s. Miller Brothers furniture store was established at the northeast corner of Ninth and King Streets, a site where it stayed for many years. The Young Women's Christian Association was located next door, while the Beacon Business College was lodged on the Tenth and King Streets corner. Beacon Business College would merge with Goldey College on Market Street and by the 1990s would move its campus to Hockessin, Delaware.

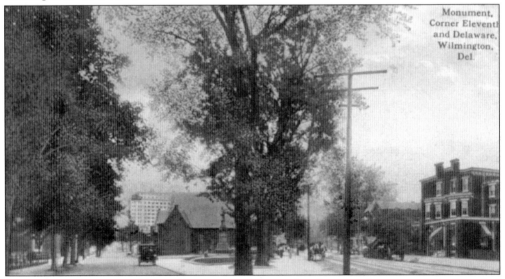

Ever since Joshua T. Heald, a Wilmington real estate developer and creator of the Board of Trade, had trolley tracks laid out Delaware Avenue, the location lured the city's well-to-do to build their residences along its tree-lined streets, offering quiet and grandeur away from the bustle of downtown. The Swedenborgian Church, founded in the mid-19th century by Daniel Lammot, was located on Eleventh and Washington Streets, with Eleventh Street running parallel to Delaware Avenue. The Brandywine Building and the new home for Wilmington Trust are currently at this site.

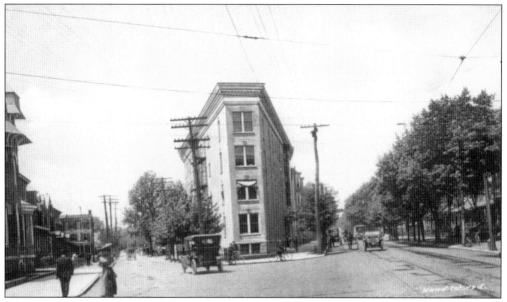

The Flatiron Building went up around 1912 on Delaware Avenue and was known as the Marion Apartments. The building survived the widening of Delaware Avenue in 1916 by DuPont Company president Pierre S. du Pont, who was commuting from Longwood Gardens in Pennsylvania at times, but it did not survive a 1972 fire. After serving a time as a parking lot, the site became home to O'Friels Irish Pub. (Courtesy of the Hagley Museum and Library.)

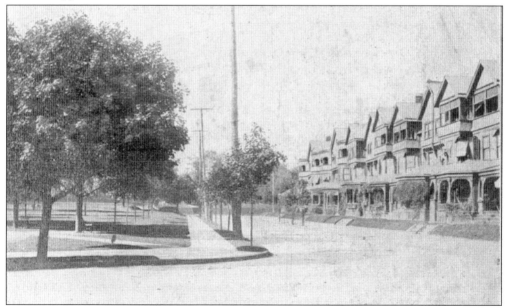

The first three blocks running west from Market Street at Tenth is still known as Tenth, and Delaware Avenue begins just beyond. Tenth Street picks up again past the Flatiron Building and comes to a dead end at the Cool Springs Reservoir at Van Buren Street. A row of stately brick houses with porches all face Tenth Street Park with its tree-lined paths and fish ponds. Tenth Street continues on the other side of the reservoir at Harrison Street.

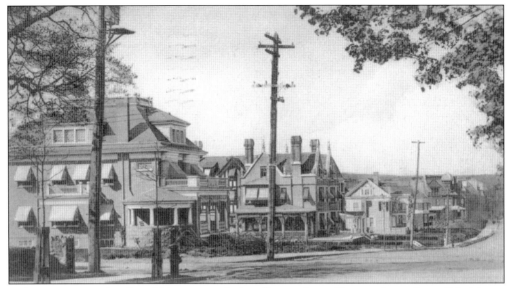

Delaware Avenue by the 1890s was settled as far north as Clayton Street by solid citizens such as Edward Gilpin (Delaware chief justice), Henry Seidel Canby (editor of the *Saturday Review of Literature*), John Biggs (prominent judge), and Washington Hastings (president of an iron plate manufactory). The mansions that lined Broom Street were typical of mansions along Delaware Avenue. Brick houses with mansard roofs or cupolas and green serpentine buildings with turrets or pointed towers sat side by side. Many of these homes still stand. Canby's house stood at 1212 Delaware Avenue and was torn down to make way for an apartment building. The houses on this 1200 block contrast those on Broom Street because they were relatively austere brick square structures, reflecting the Quaker influence of simplicity.

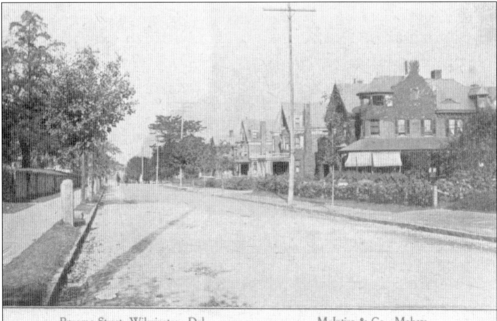

Broome Street, Wilmington, Del. McIntire & Co., Makers.

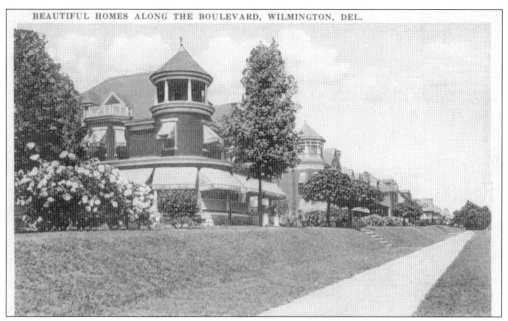

Wilmington neighborhoods initially were established along the Christina River and east and west of Market Street. Following World War II the area north of the city bordering on Eighteenth and Baynard Boulevard was developed into a residential neighborhood known as Washington Heights. The Jewish congregation built Temple Beth Shalom at Eighteenth and the Boulevard. The Jewish community in Wilmington was never very large. Jewish immigrants arrived in small numbers at the end of the 19th and the beginning of the 20th century and were laborers or in the tailoring trade. They built beautiful homes along the Boulevard, homes that are still standing in the 21st century.

Wilmington grew residentially out Twenty-ninth Street, shown here with recently constructed frame houses along a road paved with 'Bermudez Road Asphalt' as binder. The roads were no longer the cobblestone of earlier days along Market Street. These roads of 1910 were built for the automobile.

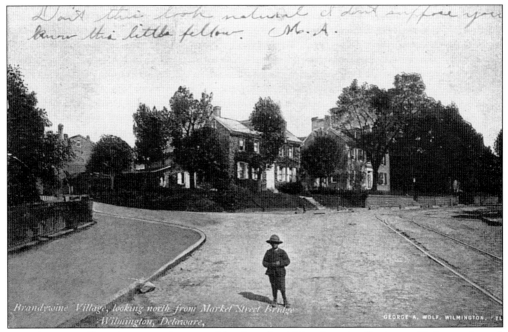

Brandywine Village was another neighborhood within the city limits at Eighteenth and Market Streets. Brandywine Village dates back to before the American Revolution, and homes seen in this view are on the National Historic Register. Joseph Tatnall, a Quaker miller, had established his mills at tidewater, which is on the Brandywine at Market Street. He is considered by many as the first great industrialist of Delaware for besides operating a flour milling concern, which his family took into the 20th century, he was president of the Bank of Delaware, the first bank to receive a charter from the state of Delaware. Mr. Tatnall was also a friend of George Washington and continued to grind flour for Washington's army on threat of being shut down by the British. As Wilmington has passed on into the 21st century, a Greater Brandywine Village Revitalization Project is active in preserving the neighborhood and its 300-year-old history. (Author's Collection.)

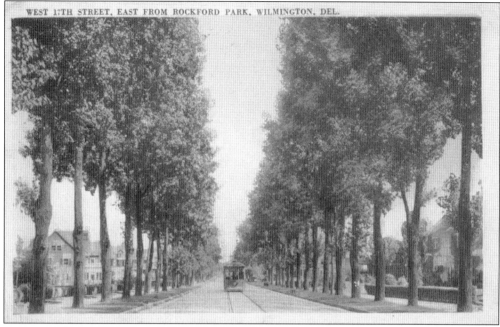

As the trolley tracks were laid ever farther out Delaware Avenue, a residential neighborhood of the Highlands developed. The Wilmington City Railway extended tracks to Union Street and then Seventeenth Street to the Rising Sun Village. Along Seventeenth Street of the 1940s, which runs parallel to Delaware Avenue, the wide roadway is punctured by the trolley tracks as grand homes sit behind a line of trees on the street. These homes, many built in the 1870s, were so sumptuous that Seventeenth Street was dubbed Wilmington's "Mayfair." John Rodney Brinkle's family owned the estate "Gilbraltar" at Greenhill and Pennsylvania Avenue and subdivided the lots in 1864 as trolley service divided their property in half. They dubbed this development the Highlands.

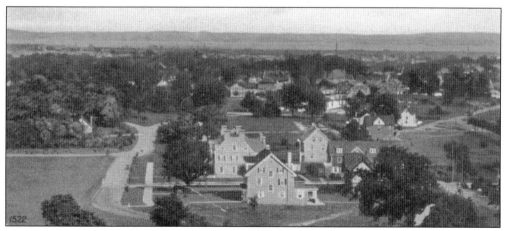

The neighborhood of the Highlands is viewed here from atop the 115-foot Rockford Tower. Businessmen, manufacturers, and their families flocked to the area by the 1880s and included George Lobdell, president of the Lobdell Car Wheel Company, and John Warner, whose family was in the shipping and cement manufacturing business. As development progressed into the 1900s, these fine homes along Red Oak Road were built.

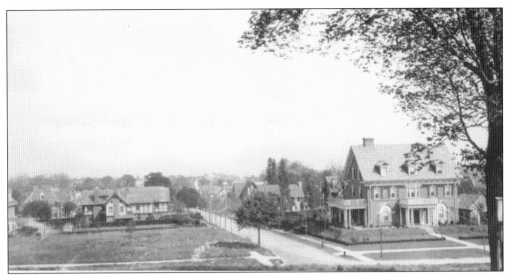

This view from Rockford Park shows the revival of colonial architecture. The water tower in the park was built of Brandywine granite in 1901 to provide water service to this ever-growing community. The tower was built with an observatory at the top so visitors could view scenic Brandywine, Highlands, and Rising Sun. (Courtesy of the Hagley Museum and Library.)

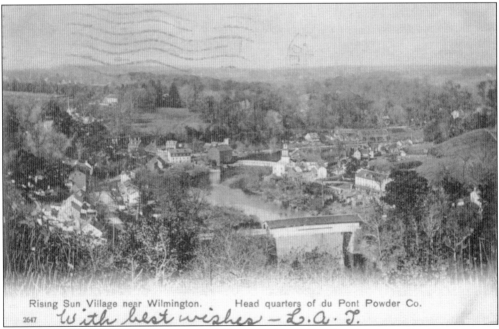

Rising Sun Village near Wilmington. Head quarters of du Pont Powder Co.

2647 With best wishes — L. a. J.

Rising Sun and Henry Clay Villages could be seen from the observatory on Rockford Tower. The Rising Sun covered bridge was built in 1833 and after more than nine decades was demolished in 1927. E.I. du Pont, founder of the Du Pont Gunpowder Works, built the villages for its employees after the works began operation in 1802. The Henry Clay Mill, in the center on the left bank of the Brandywine River, is now the site of the Hagley Museum, which is on the site of the original gunpowder manufactory.

Two

CIVIC SITES

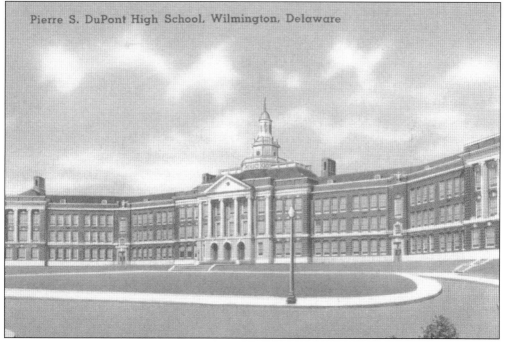

Pierre S. DuPont High School, Wilmington, Delaware

Pierre S. du Pont, a DuPont Company executive and civic activist, set out to reform Delaware education in 1917, and succeeded in building new schools and repairing old ones for both the white and black populations. By the end of the 1930s he had spent over $6 million for this effort, and in response, a grand high school was built and named in his honor in October 1935. The school eased overcrowding at Wilmington High School by accommodating 2,000 students from the city. It is currently an elementary school. (Author's Collection.)

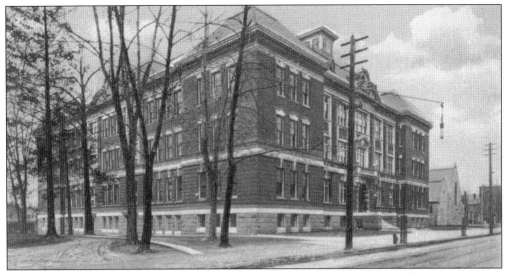

Wilmington High School was the city's first high school and was built in 1899 on Delaware Avenue across from the Wilmington and Brandywine Cemetery. An addition was built in 1919, and could hold 1,800 students. By 1933 there were 4,309 students enrolled, with Warner and Bayard schools housing extra ninth grade students, but by 1934, all three were too full. The building of P.S. du Pont high school eased this problem. A new Wilmington High School was built on Lancaster Avenue and DuPont Road in 1959, and the 60-year-old school was razed to make way for the Chase Manhattan Bank. (Author's Collection.)

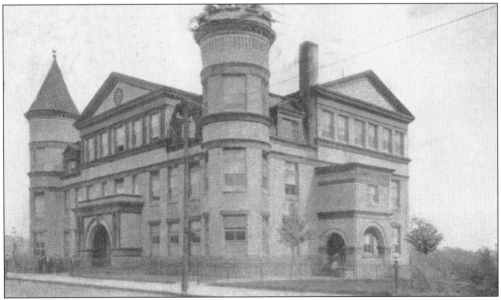

In 1852 the state legislature adopted a new law creating an elected board of education for the city. Judge Willard Hall was its first president, and the board built public schools as well as improved standards for teachers. To keep expenses low while broadening the curriculum, male teachers were slowly being replaced by females. Washington School (No. 24 School) was built on Washington Street near Fourteenth Street in 1894 overlooking Brandywine Park and has served in recent years as the board's administrative office.

The No. 28 School was also known as the Willard Hall School, built at the northwest corner of Eighth and Adams Streets in 1889. It served as a high school until 1901, when students moved to Wilmington High School. The imposing building was a showpiece of the public education system at the time. (Courtesy of the University of Delaware Special Collections.)

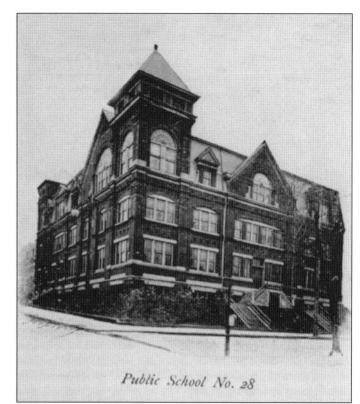

Public School No. 28

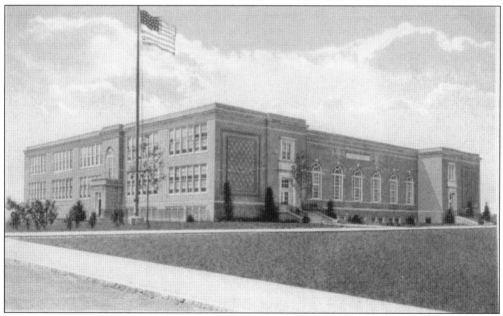

The Thomas F. Bayard School was built off Lancaster Avenue between Clayton and Du Pont Streets in the city in the 1920s. The school was named for the U.S. senator from Delaware in the 1870s. Ninth grade students were sent to this school in the 1930s to ease overcrowding at Wilmington High School. (Courtesy of the Historical Society of Delaware.)

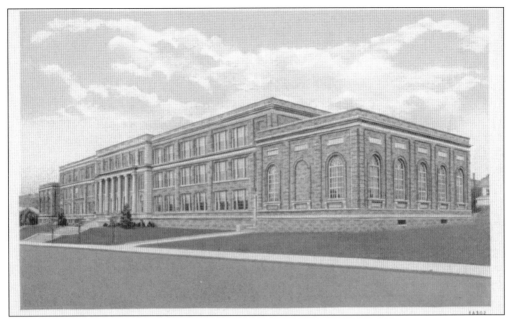

The Emalea Pusey Warner junior high school was named after Wilmington's leading social worker of the 1880s. She came from an industrial family and married into one. Because of her, the women's movement addressing social issues, called Associated Charities, effected the reform of education for all children. This school built by 1925 on Eighteenth and Van Buren Streets also served to ease overcrowding at Wilmington High School in the 1930s.

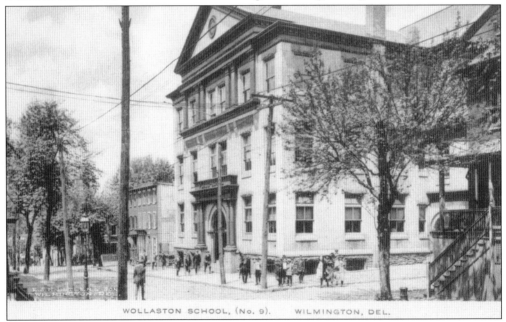

WOLLASTON SCHOOL, (No. 9). WILMINGTON, DEL.

Wollaston School (No. 9 School) was built at Eighth and Wollaston Streets in the city in 1895 as a grammar school to replace the Taylor and Jackson Academy Building. Typical of the architecture of these earlier public schools, the building was a simple square structure. (Courtesy of the Hagley Museum and Library.)

Churches in 19th century Wilmington offered both identity and a source of education to Wilmington residents. In 1814 the major denominations, including Friends, Methodists, Presbyterians, and Catholics, inaugurated Sunday schools. In 1848 the Friends built their Meetinghouse which housed the school at Fourth and West Streets. In 1817 a larger structure replaced the 1748 building. Henry Seidel Canby walked to the school with his friends from his home on Delaware Avenue in the 1890s. The Wilmington Friends had a bigger school built northwest of the city in a residential neighborhood known as Alapocas in the 1938. As Wilmington moves into the 21st century, church-affiliated schools still serve educational needs.

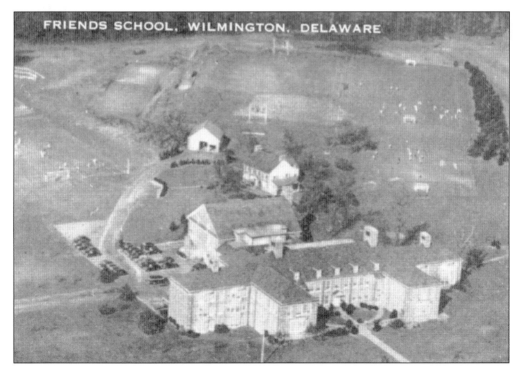

FRIENDS SCHOOL, WILMINGTON, DELAWARE

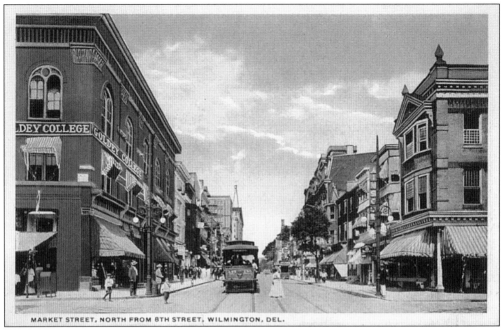

MARKET STREET, NORTH FROM 8TH STREET, WILMINGTON, DEL.

Goldey College, Wilmington's commercial college, was housed at Eighth and Market Streets at the turn of the century. The college, originally known as the Wilmington Commercial School, opened to five students in 1886 by business educator H.S. Goldey. It served the ever-growing business community concentrated downtown, as businessmen, lawyers, and retailers needed trained employees to help with both administrative and clerical duties. The school moved to a new building at Ninth and Tatnall Streets by the 1920s. One of Mr. Goldey's students, W.H. Beacom, founded a competitive business school in 1900 at Tenth and King Streets. Goldey merged with Beacom Business College in 1951 at Tenth and Jefferson Streets. (Above: Author's Collection.)

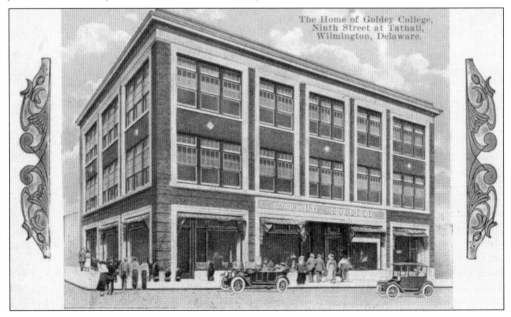

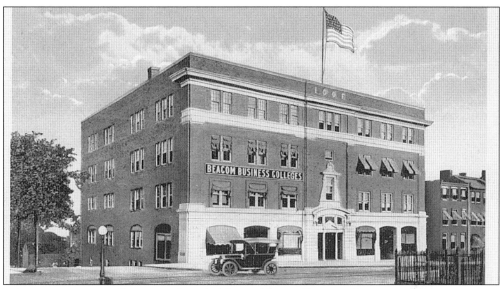

Beacom Business College was founded by Goldey College student W.H. Beacom in 1900 and operated out of the I.O.O.F. building at Tenth and King Streets. Mr. Beacom taught his students the now-standard Gregg shorthand system. For 50 years the two business schools were competitors, until they merged in 1951. Goldey Beacom College was located at Tenth and Jefferson until 1974, when the school moved to a new facility in Pike Creek Valley south of Wilmington.

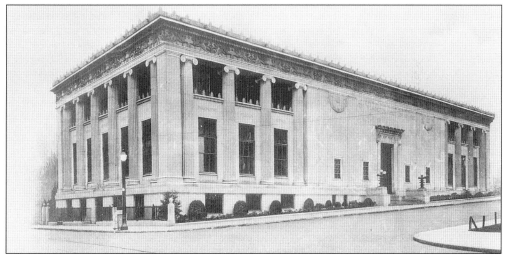

The Wilmington Institute was founded in 1860 to encourage "a taste for reading and mental culture," as stated by its charter members. Professionals and manufacturers alike embraced this institute, and by 1868, it had almost 600 members. By 1900 the institute was outgrowing its quarters at about the same time that the DuPont Company was negotiating to move into the city. The new Wilmington Institute Free Library would be located in Rodney Square Park on Tenth Street between Market and King Streets. Pierre S. du Pont, who persuaded the First Presbyterian Church to move from that location, donated the land for the library and took an active role in its architecture, since it was to be in harmony with the other buildings on the square. The library was opened in 1923. (Courtesy of the Hagley Museum and Library.)

41

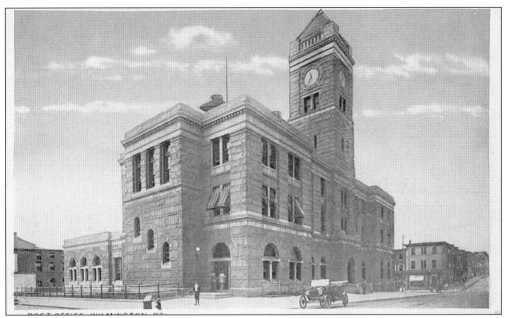

The Wilmington Post Office, built in 1887, was housed in a Romanesque Federal building made of Brandywine granite at Ninth and Shipley Streets. By 1937 it had moved to a new Federal building with the courthouse and custom house at the fourth side of Rodney Square. The Ninth and Shipley Street building was demolished. The block of Eleventh, Twelfth, Market, and King Streets belonged to the McComb-Winchester families, and the desire to fill in this location with a public building came to fruition when the United States Congress passed a bill that provided $100 million for an emergency relief fund. Wilmington would receive approximately $1.5 million for a new Federal Building. The Associated Federal Architects designed the building to conform to the classical structures on the square. Construction began in September 1935, and some local labor helped to complete it by January 25, 1937. The building in recent years has shared space with the Wilmington Trust Company, whose new home will be on the site of Wilmington's No. 2 School.

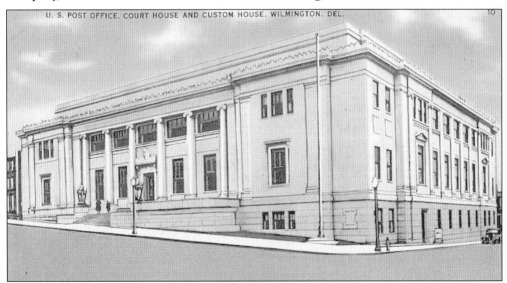

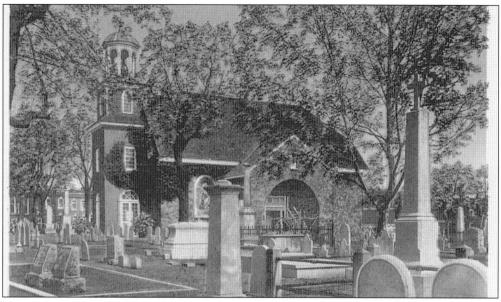

Old Swedes Church was built of Brandywine granite in 1698 and is Wilmington's oldest surviving church still used for that function. The church was not erected by the first permanent settlement of Swedes to come in 1638, but by the Swedish Lutherans led by its first pastor, Rev. Eric Bjork, who named the church Holy Trinity. Reverend Bjork preached at the first Swedish Lutheran Church at Crane Hook, near the Port of Wilmington, which was moved behind Fort Christina. The Swedish Lutheran Church came to an end in 1791 when the last Swedish minister, Lawrence Girelius, sailed away. The Protestant Episcopal Church then took over Old Swedes. The Delaware Swedish Colonial Society holds its annual St. Lucia Festival inside the church the second Sunday in December. It is the celebration of the winter solstice and tells the story of how patron Saint Lucia, the "saint of light," saved the people of Varmland, a Swedish province. The interior of the church has changed little from this view of it in the 1940s. (Author's Collection; courtesy of the Hagley Museum and Library.)

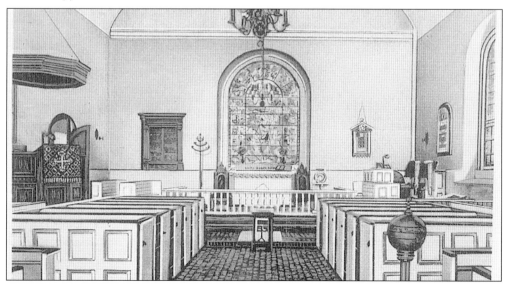

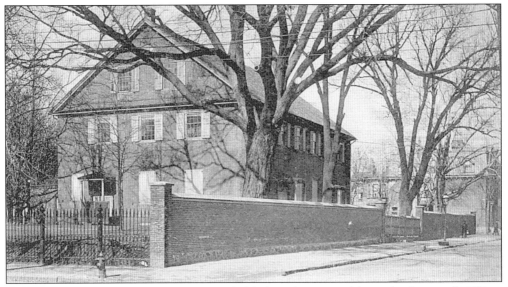

The Friends of the Wilmington Meeting held their first assembly at the home of William Shipley at Fourth and Shipley Streets. Shipley donated land for a new Friends meeting place at Fourth and West Streets, and a new building was built there in 1748. The present Meetinghouse was built in 1817 and designed by Benjamin Ferris. In 1827 the Friends of Wilmington split, with one group following Elias Hicks, becoming known as the Hicksites. There is a large burying ground by the Meetinghouse, which comprised the block of Fourth, Fifth, West, and Washington Streets.

The Swedenborgian Church or First Society of New Jerusalem was founded in Wilmington around 1824 by Daniel Lammot, a Philadelphia cotton manufacturer whose daughter married into the du Pont family. The church stood at Delaware Avenue and Eleventh Street near Washington Street but was moved to its present location at Pennsylvania Avenue and Broom Streets in 1917 as a result of the widening of Delaware Avenue in 1916. The church was moved stone by stone and erected in the same form on the new site. (Courtesy of the Hagley Museum and Library.)

The second denomination to gain a permanent foothold in Wilmington was the Episcopal Church. The Church, located at Fourteenth and Orange Streets from 1841 to 1944, served as the home of the Episcopal Bishops of the Diocese of Delaware. It was originally built by Oliver Canby in 1741. In 1944 the Diocese purchased the former home of Joseph Bancroft, whose textile mills operated nearby, at 7 Woods Road, Rockford. The original Bishopstead was flanked by its own chapel. (Courtesy of the University of Delaware Special Collections.)

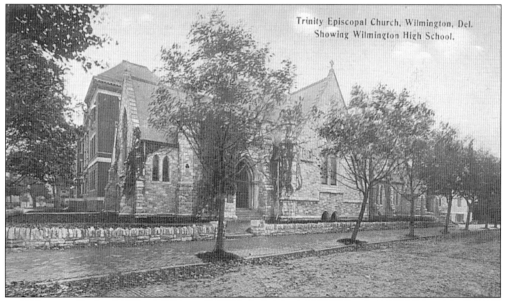

Trinity Episcopal Church was built at the corner of Delaware Avenue and Adams Street in 1882 after the Trinity Chapel property at Fifth and King Streets was sold. The church was built of Brandywine granite, a stone found in many of Wilmington's older buildings, and measured 40 by 82 feet. A rectory was built opposite the church. The present church was built in 1889, and survived demolition when the I-95 highway cut through the city in 1968 between Adams and Jackson Streets.

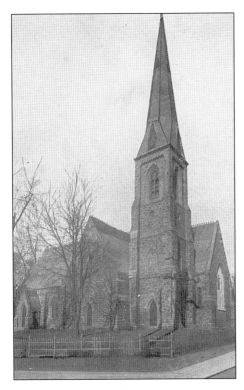

St. John's Episcopal Church was built at the corner of Market Street and Concord Avenue in 1857 on the site of the Green Tree Inn, a longtime gathering place for the Brandywine Village coopers. Alexis I. du Pont was a major contributor to the church and chose John Notman, a Philadelphia architect of Scottish descent, to design it. The Gothic architectural style of the church was much like that at Delaware Avenue and Adams Street, making use of Brandywine granite.

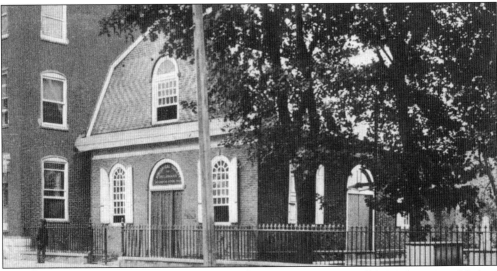

The Presbyterian Church was the third denomination to become permanently established in New Castle County. The Wilmington Presbyterians built a small brick Meetinghouse on land they purchased at Tenth and Market Streets in 1740 and also laid out a graveyard. One hundred years later a bigger church was built at the site with the smaller church becoming a Sunday school, and in 1878, it was leased to the Historical Society of Delaware. In 1916 the property was sold to the Wilmington Institute Free Library, and the graveyard remains were reinterred at the Wilmington and Brandywine Cemetery. The Meetinghouse was moved to Brandywine Park in 1922. (Courtesy of the Hagley Museum and Library.)

Hanover Presbyterian Church became the Second Presbyterian Church in 1772 and moved from Fifth and Walnut Streets to the Corner of Eighteenth and Baynard Boulevard, a neighborhood known as Washington Heights, where it still functions as a church. (Courtesy of the University of Delaware Special Collections.)

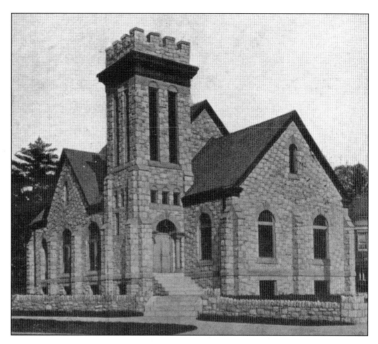

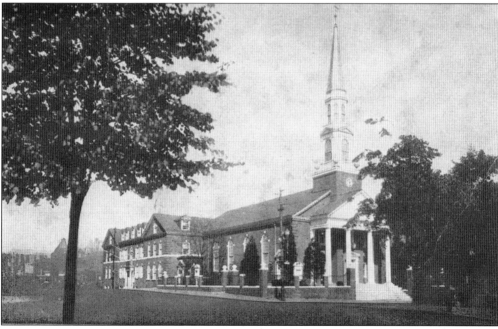

The First and Central Presbyterian Church was formed by a merger that took place in 1919. By 1928 the congregation had purchased the Draper property at the northwest corner of Eleventh and Market Streets, and the new church was dedicated over a six-day period in the fall of 1930. The church is equipped with numerous rooms for activities associated with social work. The First and Central Presbyterian Church continues to play a prominent role in the life of residents around Rodney Square Park. (Courtesy of the University of Delaware Special Collections.)

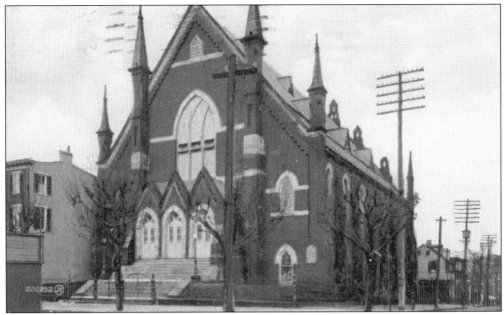

West Presbyterian Church was organized by members who split off from Central Church, Hanover Church, and First Church. The new church was constituted on October 19, 1868 and held its services in the Wilmington Institute Building at Fifth and Market Streets. In 1870 the property for the present church at Eighth and Monroe, where Central Church operated a chapel called Monroe Street Chapel, was presented to West Church by Central Church, and the new church began construction on it by the end of 1871. In the early 1990s, West Church suffered a damaging fire but rebuilt and is still ongoing.

The Baptist Church was the fourth denomination to settle permanently in Wilmington. The First Swedish Baptist Church of Wilmington was organized in 1889, and a small brick church was built at the corner of Twelfth and Heald Streets in 1893. In 1902 the church purchased a lot at the northeast corner of Vandever Avenue and Church Streets, where a new church was built in 1904. The name was changed to Grace Baptist in 1943.

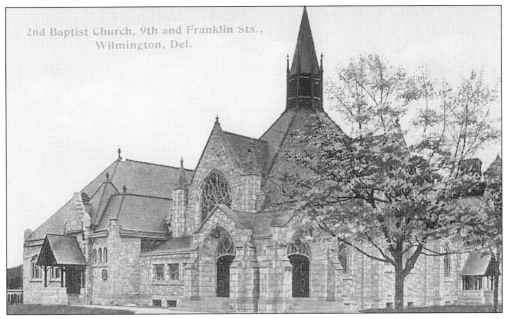

The Second Baptist Church was organized by members that split off from First Church in 1835 because of anti-mission sentiment then existing in First Church. Second Baptist members had a church built at Fourth and French Streets in 1854 but, by 1909, had a much bigger structure built at the corner of Ninth and Franklin Streets, property which had been purchased in 1891. The church currently functions at that same location. (Courtesy of the University of Delaware Special Collections.)

Delaware Avenue-Bethany Baptist Church was formed by a merging of the two in 1931. Members who split from the Second Baptist Church formed Delaware Avenue Baptist Church in 1865 and worshipped near Delaware Avenue at Tenth Street. Bethany Baptist organized in 1878 and met initially at the old Wilmington & Northern Railroad Station at Front and Madison Streets. They built their church at Elm and Jackson Streets in 1893. In 1931 Bethany sold its property to the Boy's Club after merging with the Delaware Avenue Baptists. (Courtesy of the University of Delaware Special Collections.)

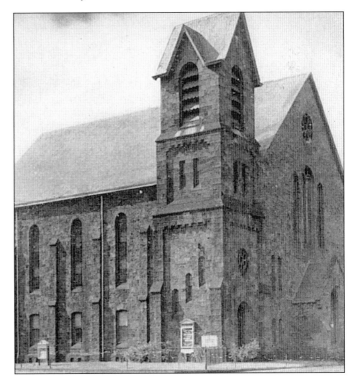

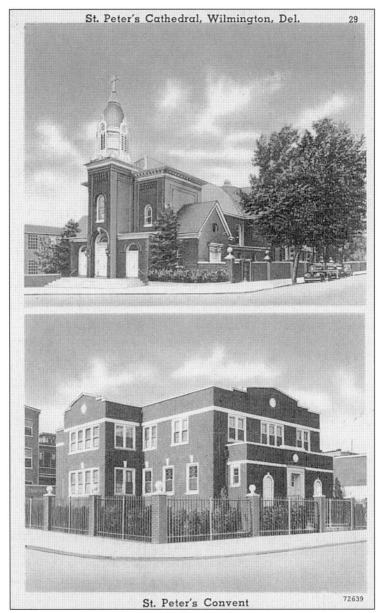

St. Peter's Convent 72639

The Roman Catholic Church is the fifth denomination to organize permanently in New Castle County. The first Catholic church built in Wilmington was St. Peter's Cathedral, built at Sixth and West Streets, not far from the Friends Meetinghouse, in 1816. Father Patrick Kenney, an itinerant priest out of Philadelphia based at Coffee Run northwest of the city, came to hold services at the church twice a month. The Rev. George A. Carroll was appointed the first resident pastor. An orphanage and parochial school were built at the site in 1830. St. Peter's was the only Catholic Church serving Wilmington residents until St. Joseph on the Brandywine was built in 1841. Assistant pastor Patrick Reilly established a school for boys between Madison and Jefferson Streets on Delaware Avenue, which became known as St. Mary's College. Reverend Thomas A. Becker and Bishop Alfred A. Curtis were two of the many who served in St. Peter's.

St. Hedwig's Roman Catholic Church was built at Linden and Harrison Streets in 1890 to serve the Polish immigrants who were coming into the city from Eastern Europe. These immigrants attended Sacred Heart Church at Tenth Street between Madison and Monroe before they had their own church. In 1904 a newer church was built on additional deeded land at its location. St. Hedwig's began an annual May festival in 1956, which has become known as the Polish Festival.

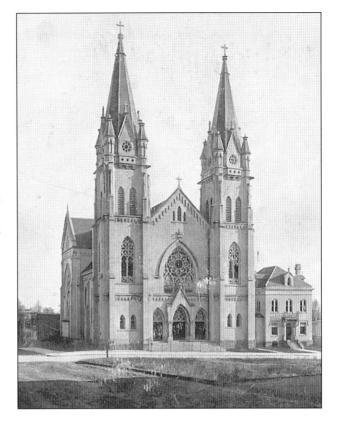

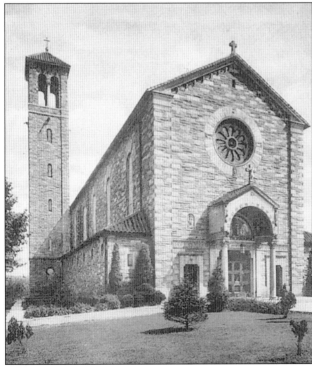

St. Anthony's Catholic Church was built in 1924 to answer the needs of the Italian immigrant community, which grew in the area bounded by Lancaster Avenue and Eleventh Street, and Union to Broom Streets. A local Irish priest, Rev. John Francis Tucker, who spoke fluent Italian, became pastor there and quickly won over the congregation who nicknamed him Padre Tuck. The St. Anthony's Italian Festival, which today runs annually for a week in June, had its beginnings in 1936 from church festivals that were celebrated. This, like St. Hedwig's, served its ethnic community.

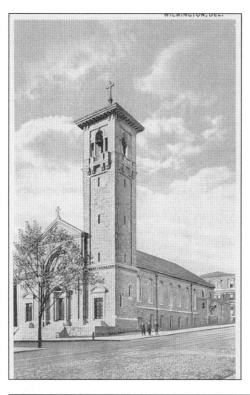

St. Paul's Roman Catholic Church is located at Fourth and Jackson Streets, and serves the predominantly Hispanic community. The church was built in 1869 and the parochial school was constructed in 1888. The church was rebuilt and was dedicated as a new church in 1914. The church survived the construction of the highway I-95 through the city in 1968.

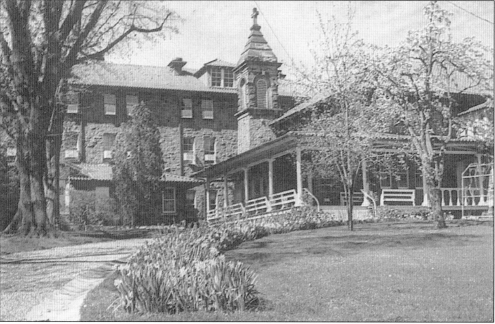

The Cloistered nuns lived and operated the Monastery of the Visitation located behind St. Ann's Church between Gilpin and Shallcross Avenues and Grant Street and Bancroft Parkway. The only time the public was ever allowed inside was when the monastery was preparing to move out in the early 1990s.

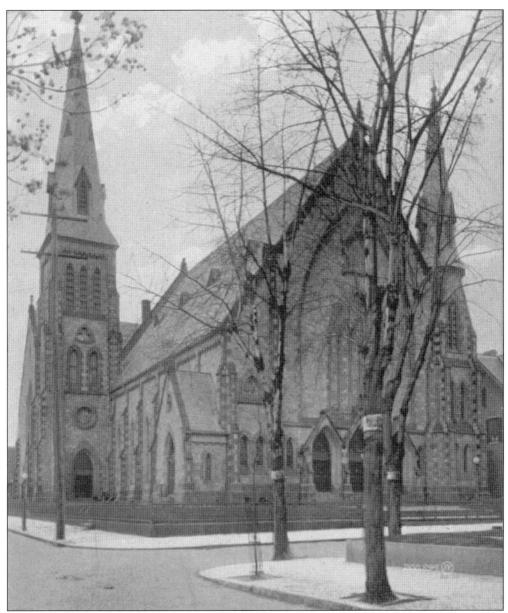

The Methodist Church was the sixth denomination to settle permanently in Wilmington, and was the fastest growing Church of the 19th century. St. Paul's Methodist Episcopal Church was founded in 1844 and built its house of worship at Seventh and Market Streets. Grace Methodist Church was born of St. Paul's in 1864 by a small group of industrial leaders, who wanted to start a new congregation. The name "Grace" was adopted on January 27, 1865. They built a church as a thankful offering to God, a monumental, fashionable building to eclipse all structures in the city and reflect the prosperity of its citizens. The church, measuring 166 feet by 102.5 feet, was built of green-tinted serpentine stone designed with decorated Gothic motifs, including two towers a block from Delaware Avenue on West Street. Grace supported missions in poor neighborhoods and continues to do much for the community.

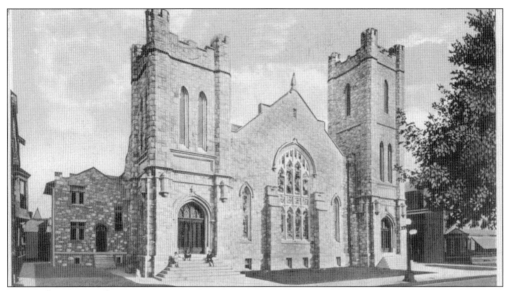

The Methodist denomination counted the greatest number in their ranks as well as having the most varied socioeconomic groups represented. The faith attracted great numbers of migrants from southern Delaware during the early 19th century. By the 1840s prominent citizens and businessmen broke from Asbury M.E. Church, and formed their own congregation by building St. Paul's Church at Seventh and Market Streets in 1845. Methodists addressed issues of social disorder in the community and were the most active at the time in doing so. In 1911 a new church at Tenth and Jackson was built to hold the growing congregation. This beautiful church did not survive the entrance of I-95 through the city in 1968 and rebuilt north of the city.

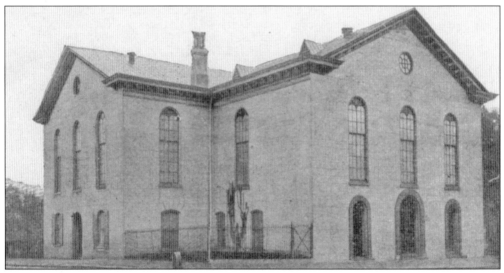

The Asbury Methodist Church was built in 1789 on the southeast corner of Third and Walnut Streets, 17 years after Francis Asbury began preaching in Wilmington. This church practiced some degree of racial integration, but tensions arose and Peter Spencer and his followers broke away to form the African Union Methodist Church in 1812. In 1885 the building was enlarged, and in 1937, five memorial windows were dedicated.

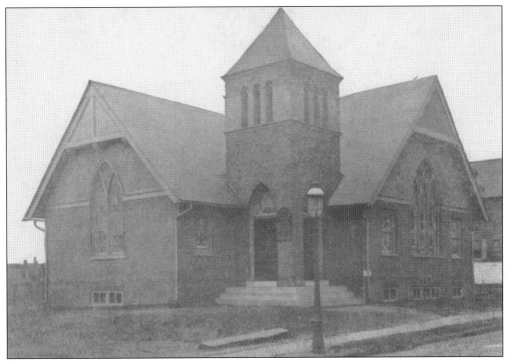

East Lake Methodist Episcopal Church, named after East Lake Park, was one of the many Methodist churches to develop in Wilmington. This one, at Thirtieth and Tatnall Streets, was built in 1890 to serve the ever-growing community, where the sidewalks then consisted of duckboards. In 1916 the church was enlarged, and in 1940, the congregation celebrated its 50th anniversary.

Mt. Salem Methodist Church was organized in 1847 and was the second church to be built to serve the Henry Clay and Rising Sun communities, whose residents worked at the Du Pont Gunpowder Works and at the Joseph Bancroft textile mills. St. Joseph on the Brandywine Roman Catholic Church was the first one built in 1841. Mt. Salem was located where it still stands today, at the edge of Rockford Park on Nineteenth Street. The 1847 church was torn down and a new one was built in 1878, only to burn down a year later. It was rebuilt immediately and underwent extensive renovations in 1906. The church's attendance has suffered with the closing of the industrial sites in the 20th century.

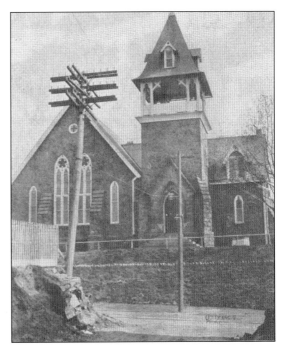

The First Church of Christ Scientist, whose religion is based on the teachings of Mary Baker Eddy from New England, was organized in Wilmington in 1902, and for a time, meetings were held at the Garrick Theater at Ninth and Market. A frame chapel was erected at Park Place and Van Buren Street in 1904. The present church was built at this same site in 1912 and dedicated in 1918. (Courtesy of the University of Delaware Special Collections.)

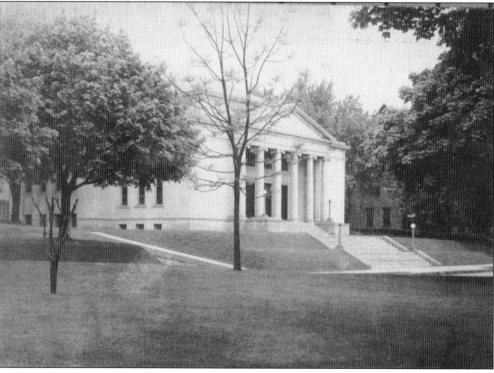

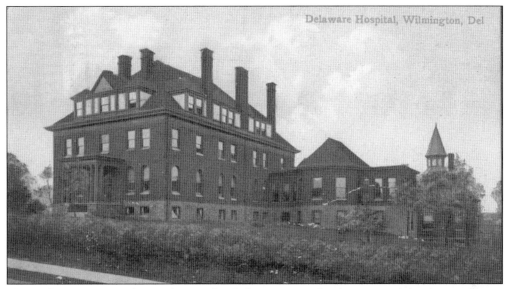

The Delaware Hospital was the result of the actions of a women's philanthropic group called the Associated Charities, formed in 1884 to coordinate the activities of Wilmington's welfare agencies. This hospital was built in 1888 at Fourteenth and Washington Streets after Mrs. J.T. Gause, the wife of a prominent Wilmington businessman, induced her husband to open a hospital for the practice of allopathic medicine. In 1893 a free dispensary was opened.

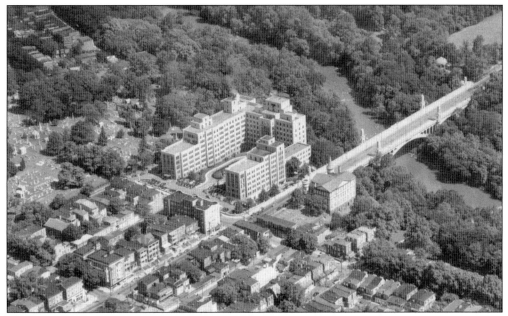

The Delaware Hospital remained and continues to remain at its Fourteenth and Washington Street location. By 1965 the Delaware, Memorial, and Wilmington General Hospitals were merged under the Wilmington Medical Center. In 1985 the new Christiana Division, and within recent years the Delaware Hospital, functions under the management of Christiana Care.

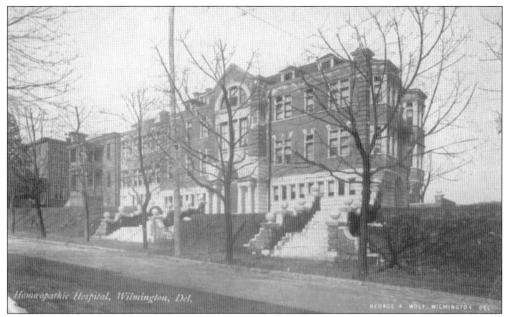

The Memorial Hospital, Wilmington's oldest, began operating as a homeopathic hospital in late 1888, thanks to the efforts of the Associated Charities, and was located close to the Brandywine River near the city, as was the Delaware Hospital. The administrative systems adopted by both hospitals included an all-male board of trustees, but an all-female board of managers. The homeopathic hospital was located on Van Buren Street and Lovering Avenue.

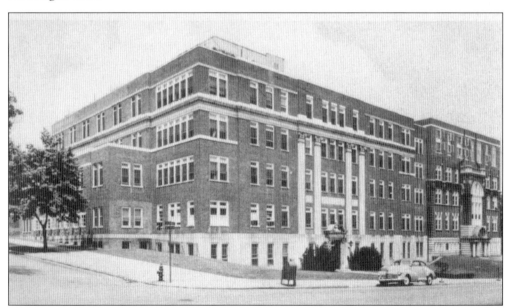

The Memorial Hospital was one of Wilmington's hospitals merged under the Wilmington Medical Center in 1965. In 1985, when the Christiana Division in southern New Castle County opened, Memorial Hospital was closed and was imploded the following year. (Courtesy of the University of Delaware Special Collections.)

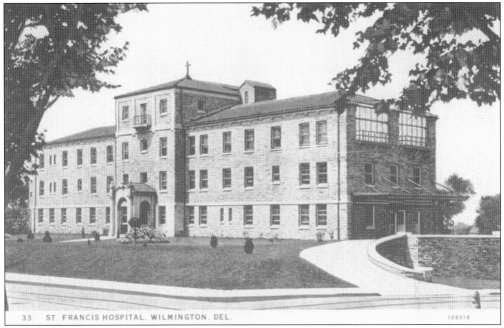

St. Francis Hospital is located at Fifth and Clayton Streets. It is a Catholic institution and was not included in the merger of the larger three hospitals in 1965. It was founded early in the 20th century.

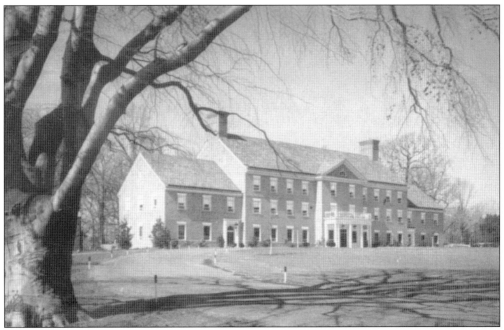

Pelleport, once the estate of Eugene du Pont and his family, became a physical therapy hospital in the 1970s, and in the late 1990s, it became a part of Christiana Care. Pelleport is located on Route 52 near Greenville, just a few miles north of the city. (Courtesy of the Historical Society of Delaware.)

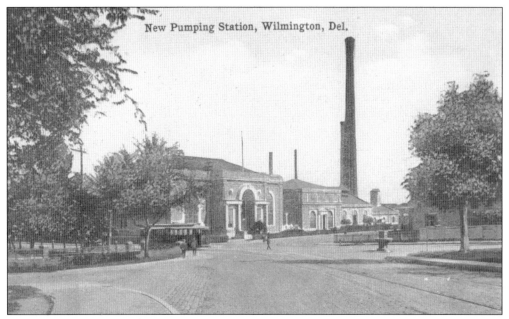

New Pumping Station, Wilmington, Del.

The Wilmington Water Pumping station sits at Sixteenth and Market Streets opposite the entrance to Brandywine Park. In 1827 water was pumped from the Brandywine River at this site to the reservoir that is now Rodney Square. That reservoir was drained in 1878 and two others northwest of the city were constructed. The pump house was built in 1872 to lift water from the Brandywine to these two reservoirs. Wilmington's station underwent upgrades to its system when the Brandywine Race was constructed in 1900 to feed water to the station and later the Buffalo (NY) firm of the Buffalo Gasolene Motor Company installed three "Buffalo" engines, which supply both primary and emergency power for pumping. The water station is at the intersection where Price and Phillip mills of the 19th century operated, across the Brandywine River from Joseph Tatnall's mills.

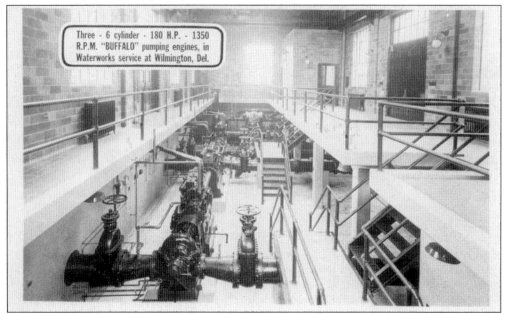

Three - 6 cylinder - 180 H.P. - 1350 R.P.M. "BUFFALO" pumping engines, in Waterworks service at Wilmington, Del.

Cool Spring reservoir and pumping station, having a capacity of 40 million gallons, was built between 1873 and 1877 at Tenth Street between Van Buren and Franklin in response to the demand for water by residents moving north and west of the city. The wooden pipes bringing water up from the Brandywine to the Tenth and Market reservoir were near collapse, so Cool Spring was a necessity.

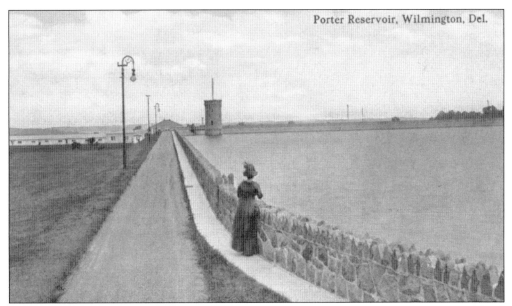

Porter Reservoir, Wilmington, Del.

Porter Reservoir was an addition to Wilmington's water supply system when it was built after 1900 at a high point on Concord Avenue called McKee's Hill. The reservoir is a 35-million-gallon sedimentation reservoir serving as the city's main holding area. Wilmington's population at this time was near 80,000.

61

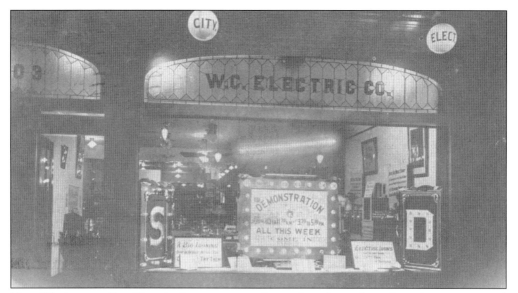

The Wilmington City Electric Company was located at Seventh and Market Streets and evolved as a part of the city's transit system. Since trolleys were the first major generators of electricity, the transit systems provided both trolley service and electric power. Mergers of transit and power companies culminated in 1910 in the creation of the Wilmington and Philadelphia Traction Company, which included among its holdings the old Wilmington City Railway Company, the Wilmington City Electric Company, the Wilmington Light and Power Company, and five years later, the Peoples Railway Company.

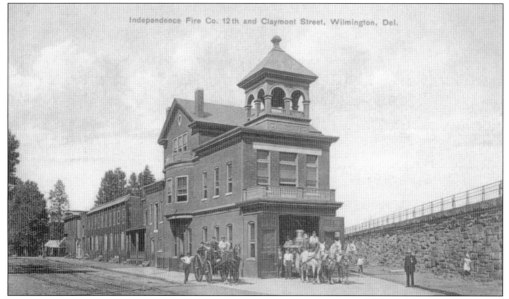

Wilmington's early fire companies functioned between 1775 and 1869, and were often fraught with such competition that buildings could burn down because the firefighters were busy fighting each other. The Independence Fire Company was built at Twelfth and Claymont Streets, east of the city, in the 1890s, and operated horse-drawn steam water pumping engines.

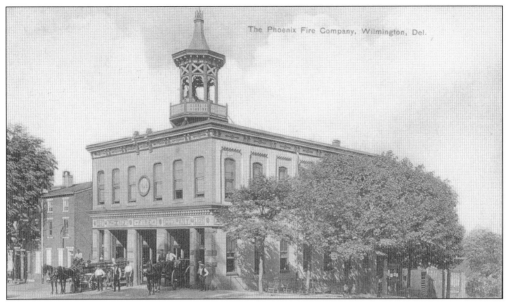

The Phoenix Fire Company was the fourth fire company to be founded in Wilmington. The company built its firehouse near Brandywine Village on the south side of the Brandywine at Twelfth and King Streets. The Brandywine Fire Company was founded early in the century and served Brandywine Village; it also contributed money and equipment to the Phoenix Fire Company. This company celebrated its 50th anniversary in 1875 with a street parade and a banquet. The company survived into the 20th century.

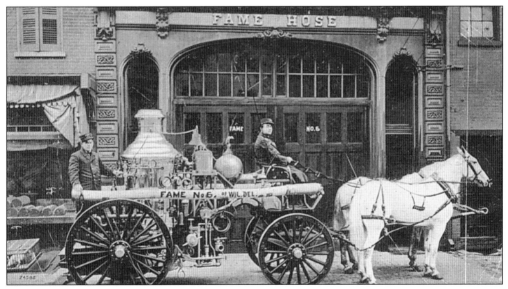

The Fame Fire Company was the sixth fire company to serve the city. It was founded in 1839 at the north side of Second Street near Market Street. The company got its name from the Fame Fire Company of Philadelphia, from whom they purchased a hose carriage for $350. In 1873 a three-story engine house was completed at the cost of $13,000. In 1846 Fame was composed mostly of owners of real estate. By 1890 this company had over 250 members and real estate, equipment, and horses worth about $23,000.

The Presbyterians built a small Meetinghouse in 1740 on Market Street near Tenth Street. A bigger church was built in 1840, and the Meetinghouse was used as a Sunday school until January 1878, after which it was rented to the Historical Society of Delaware. The Historical Society remained there until 1917, when both the small and large churches were vacated to make way for the Wilmington Institute Free Library and the Delaware Trust Building. The Meetinghouse was moved into Brandywine Park where it serves as the headquarters for the Colonial Dames of Delaware.

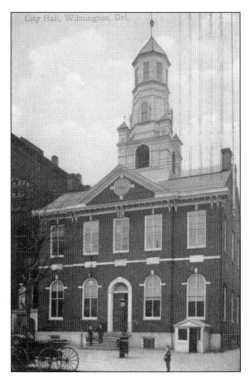

Old Town Hall, built in 1798 on Market Street above Fifth, served as Wilmington's city hall until 1916, when city hall moved to its new quarters on Rodney Square. The Historical Society of Delaware, which had to move out of the Presbyterian Meetinghouse, took over Old Town Hall as its headquarters. In 1875 the Federal-model cupola was replaced by this enlarged gingerbread model. In the 1960s old town hall became one of a number of buildings called Willingtown Square, which operates currently under the Historical Society of Delaware.

The Irish American Hall was located at 608 French Street near the German Hall. The Irish and Germans constituted two of Wilmington's largest ethnic groups, and these halls offered a place where they could congregate and keep their cultures alive. Patrick R. Mulrooney operated the Irish American Hall from 1916 until 1931. It served as a saloon as well as a gathering place of supporters for the independence of the Republic of Ireland. Mulrooney moved his hall to Elsmere in 1931, where Mulrooney's Café operates today.

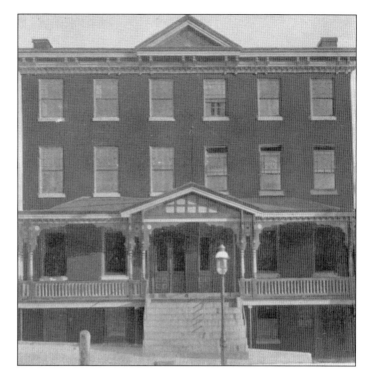

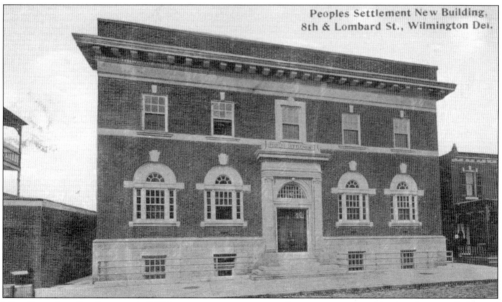

Peoples Settlement New Building, 8th & Lombard St., Wilmington Del.

The Peoples Settlement of Wilmington was a social service agency located at Eighth and Lombard Streets. Sarah Webb Pyle, a follower of evangelist Dwight Moody, founded it in the 1890s in the house where she ran a kindergarten and offered classes in sewing, gardening, and music. The settlement's most popular activities were its boys and girls clubs. In the 1960s, when the city was attempting a redevelopment-housing scheme for Wilmington's east side, the Peoples Settlement spoke for the poor people it represented, voicing their frustration at the delays caused by the political climate.

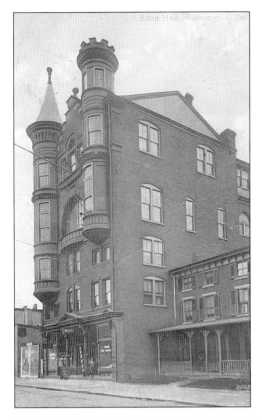

Eden Hall Lodge, located at 206 West Tenth Street, was an imposing building in Wilmington's skyline after it was built in 1889. It stood across from the DuPont and Nemours Buildings built between the 1910s and 1930s. The local architect who designed this building referred to the architecture as "Norman Gothic." The interior boasted a massive stairway and large rooms for banquets and gatherings.

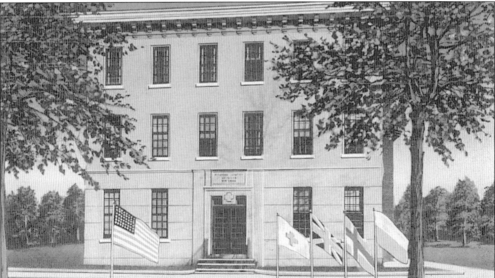

The home of the Delaware Chapter of the American Red Cross was located at 911 Delaware Avenue by the 1940s. The Red Cross workers and volunteers worked on a 24-hour schedule turning out thousands of knitted and sewn clothing, giving First Aid classes, and attending to the needs of the soldiers during World War II. The building stood across from what is now the Children's Theater on the Avenue.

Three

SOCIAL LIFE

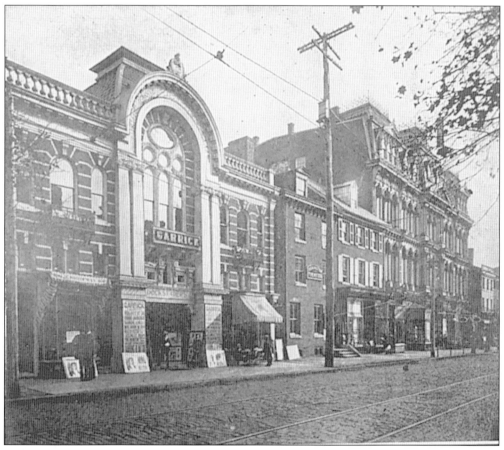

William L. Dockstader (performer-manager) was the first to show the moving picture *The Kiss,* featuring May Irwin, in his Wonderland Music Theater at Seventh and Shipley Streets in 1895. In 1903 he had the Garrick Theater at 828–830 Market Street built, where he offered both live theater, vaudeville, and movies. The first movie shown there was *The Great Train Robbery*. During the lifetime of the Garrick only silent films were shown. Warner Brothers bought the theater in 1930, showing as its last film *Royal Rider*. A familiar figure in front of the theater was the candy man in a white suit, hat, and gloves. (Courtesy of the Hagley Museum and Library.)

The Majestic movie theater was one of over 30 theaters in the city during the 20th century. It opened at 703 1/2 Market Street in 1911 in the building formerly occupied by St. Paul's Methodist Church. It was the only theater to operate in the 700 block of Market Street. The theater was built by a local firm, John A. Bader and Company, who would construct the Playhouse two years later. The theater had a massive marble marquee, electric lights at the entrance, and could seat 1,000 patrons. Warner Bros. bought the building in 1925 and leased it to W.T. Grant and Company for 20 years. Adelord J. Belair was the assistant manager there and he would go on to manage the Rialto on the 200 block of Market Street.

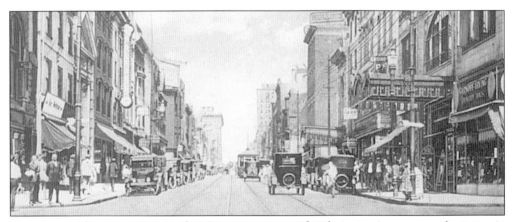

The Queen Theater at 500 Market Street was one of Wilmington's most opulent movie palaces, with every luxury to draw the moviegoer. The Wilmington Amusement Company built the theater within the walls of the Clayton House in 1916 at a cost of $250,000. The theater could seat 2,000 patrons. The walls along the lobby and ramp were of Alaska marble, the stage was 64 by 40 feet, and murals were visible above the 40-foot proscenium arch. There was a large gold dome in the ceiling above the auditorium concealing electric fixtures. This theater was also sold to Warner Bros. in 1925. The Queen Theater held Wilmington's second world premiere, *Always in My Heart*, starring Kay Francis and Walter Houston in 1942. In 1952 the Avon Motion Picture Company bought the Queen, but competition with Warner theaters forced its closure in 1959.

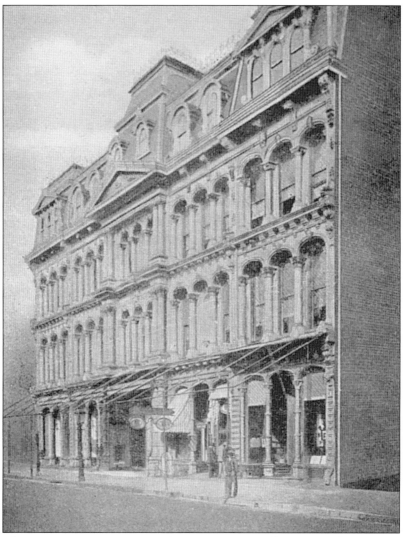

The Grand Opera House, constructed in 1871, was Wilmington's first theater for live performances, musicals, and drama, opening on the ground and second floors of the Mason's temple at 818 Market Street. It was designed by Thomas Dixon and Charles L. Carson of Baltimore in the French Second-Empire style and stood 211 feet by 92 feet. The richly ornate façade was of a finely finished cast-iron that was painted white to imitate chiseled marble. The interior boasted a horseshoe balcony, having a golden rail arching around it and a broad ceiling mural. It sat 1,400 people. In 1896 the Grand featured the Lumieres' Cinematographe, then four months later it presented Edison's Vitascope, both of these the latest in moving-picture technology. The Harris Amusement Company took over management of the Grand in 1909, and by 1910, live performances took second place to the movies, and thus the Grand was converted into a movie house. A blow to the Grand was when the Philadelphia Orchestra transferred its musical series to the Playhouse in 1913. The Grand became a second-run movie theater, showing mostly westerns and newsreels, after Warner Bros. took it over in 1930. In 1967 the last movie was shown at the theater and in 1976 the move was on to return the Grand back to the Grand Opera House. (Courtesy of the Hagley Museum and Library.)

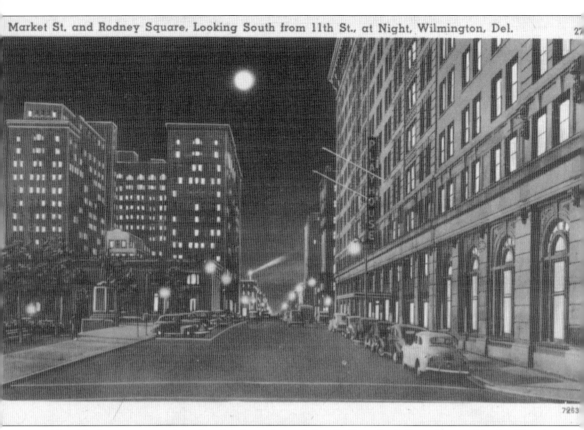

7263

The Playhouse opened in the third section of the DuPont Building along with the Hotel du Pont in 1913. The Playhouse was never a movie palace, nor did it ever compete with Wilmington's movie theaters, although it is known for the quality of movies shown there. The Playhouse could seat 1,256, and its first play was George Broadhurst's *Bought and Paid For*. The local firm, John A. Bader and Company built the Playhouse in 150 days, an extraordinary effort. A huge electric sign with the word "Playhouse" was erected on the Market Street entrance. That sign is gone, but the Playhouse is very much a part of Wilmington's cultural scene. (Author's Collection.)

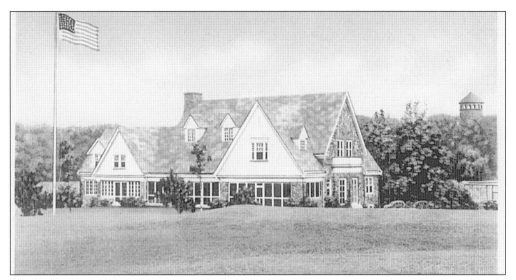

The DuPont Company Experimental Station began at its site on the Brandywine River bordering Rockford Park in 1906. DuPont was entering a new era, which saw the diversification of its products away from explosives, and the Experimental Station became the company's stage. The company workforce was expanding with the hiring of chemists, managers, sales people, and administrative help. By 1920 the DuPont Country Club was organized for its employees, which then numbered 3,700. The club house and golf course was housed in the oldest building on station property and faced Rockford Park where Rockford Tower could be seen. In 1940 the DuPont Company built a new and much bigger country club and an 18-hole golf course to allow for expansion of the Experimental Station. The clubhouse was built on the north side of Rockland Road about a half mile west of Rockland and Newbridge (Route 141) Roads at a cost of about $400,000. It is of Georgian colonial style and was constructed of structural steel, brick, and concrete with an exterior of white-faced colonial brick. In 1940 the clubhouse was about 400 feet long and 120 feet wide. A major annual event in recent years at this country club is the LPGA Golf Tournament benefiting the Ronald McDonald House for children. (Courtesy of the Historical Society of Delaware.)

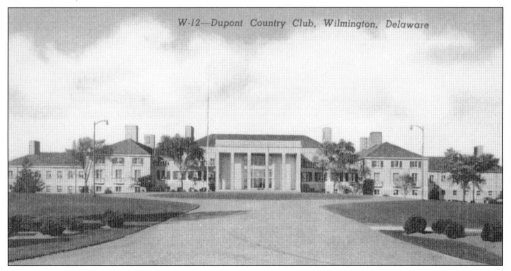

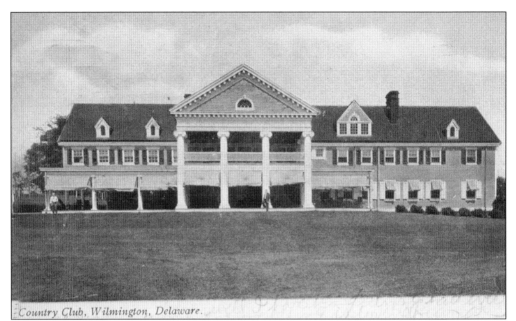

Country Club, Wilmington, Delaware.

The Wilmington Country Club and golf course was built in 1901 at Greenhill Avenue and Pennsylvania Avenue by the Delaware Field Club, the so-called social set, which leased the land from William du Pont and laid out Wilmington's first golf course and an imposing clubhouse. The field club reorganized into the Wilmington Country Club and has remained a prominent gathering spot for the city's social elite. The country club will celebrate its 100th anniversary in 2001. The original Georgian–style clubhouse (top) burned in 1924, was rebuilt (bottom), and sold in 1959. The club then moved its quarters north of Wilmington. (Courtesy of the Hagley Museum and Library.)

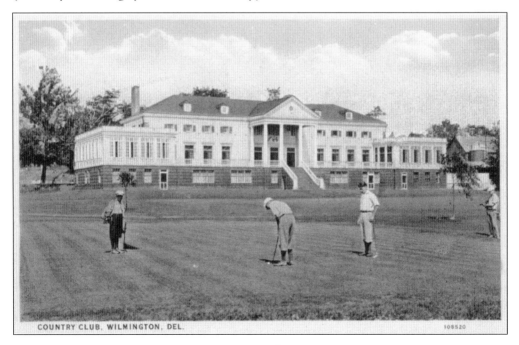

COUNTRY CLUB, WILMINGTON, DEL. 108520

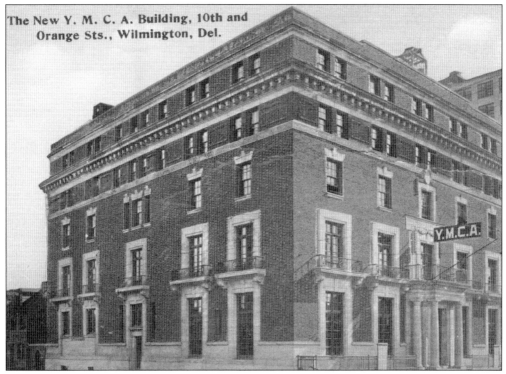

The New Y. M. C. A. Building, 10th and Orange Sts., Wilmington, Del.

The Young Men's Christian Association gained a foothold in the city of Wilmington in the 1890s with its new brick building at Tenth and Orange Streets. The YMCA offered varied athletic and social programs and provided inexpensive but respectable housing for young people. In 1930 this building was demolished to make way for the sixth section of the DuPont Building.

The new YMCA building was constructed in 1928 at Eleventh and Washington Streets on the site of one of Wilmington's finest old stately mansions, belonging to Job Jackson, one of the founders of the Jackson & Sharp Company, which built railroad cars.

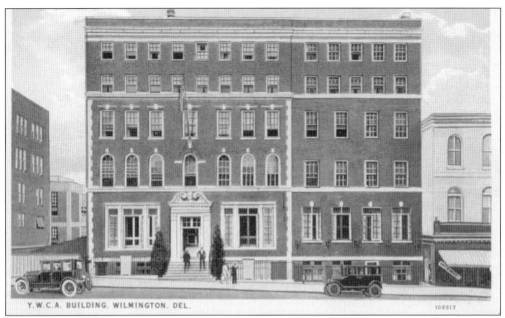

Y.W.C.A. BUILDING, WILMINGTON, DEL. 108517

The Young Women's Christian Association was also founded in Wilmington in the 1890s, and had their building on King Street near Tenth Street beside Beacon Business College. The YWCA remained at this location until it moved to new quarters at Third and King Streets in the 1990s to make way for a new office building at the southeast corner of Tenth and King Streets.

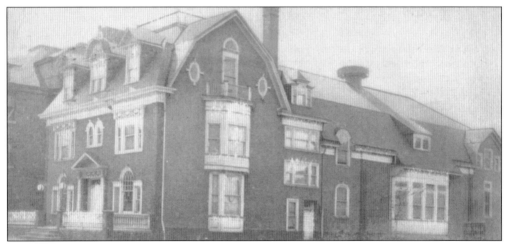

Upper middle-class women of Wilmington who desired to be more involved in activities outside the home resulted in the founding of the New Century Club in 1889. It offered a blend of intellectual, social, and charitable outlets for these wealthy patrons. The leading figure in the club's early history was Emalea Pusey Warner, a member of a leading industrial family and a social worker who has a junior high school named after her. Although this group of 300 was elitist, for it restricted membership, it was concerned with problems in the community. The club sponsored concerts, lectures on art and literature, and speakers on current affairs. The club was in the building that currently houses Wilmington's Children's Theater.

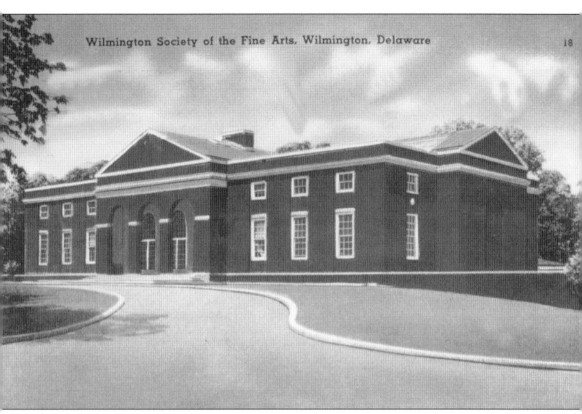

The Wilmington Society of the Fine Arts was founded in 1919 and was housed in the Library Building at Tenth and Market Streets from 1919 to 1937 when a new building at Park Drive and Woodlawn Avenue was built. Local architects Whiteside and Homsey designed the building. The building was called the Delaware Art Center and houses collections by some of Wilmington's local artists, such as Frank Schoonover, Howard Pyle, N.C. Wyeth, Andrew Wyeth, John Sloan, and Edward Hopper. The name was changed to the Delaware Art Museum and stands on Kentmere Parkway and Woods Road. (Courtesy of the University of Delaware Special Collections.)

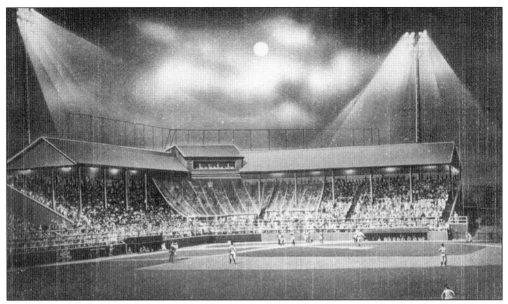

Entertainment in Wilmington outside of the realm of the arts was found in baseball. Baseball was introduced in Wilmington in 1865, and the Diamond States, made up of those who had the time and money to invest, became Wilmington's first team. By the 1870s baseball became a game loved by all social classes and was a sport loved by both the professional and the amateur player. The Wilmington Blue Rocks became Wilmington's minor league team in the 1940s, playing at the Wilmington Ball Park at Thirtieth Street and Northeast Boulevard. The team was gone by the 1950s and the park was torn down. The Wilmington Blue Rocks went back to bat again in the late 1990s at Wilmington's Frawley Stadium on Madison Street. (Courtesy of the University of Delaware.)

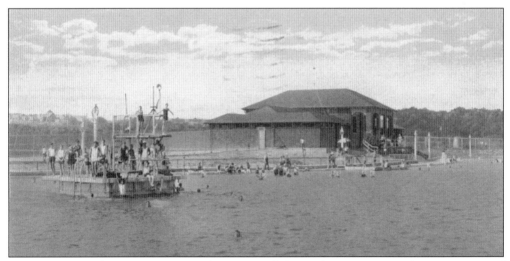

Included in outdoor activities in Wilmington of the 20th century was the innovation of the municipal swimming pool. Travel to seaside resorts or parks, such as the Brandywine Springs Park, offered the chance to go swimming, but for those who could not get away, the municipal pool offered the answer after the 1940s. Pools were initially built in city parks and the municipal pool is the outgrowth of that.

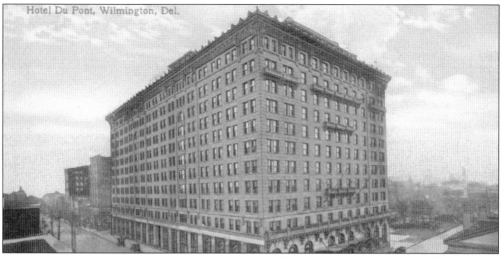

On January 15, 1913, when the Hotel du Pont officially opened to the public, the local newspaper claimed it as a dream come true for it was a fine up-to-date hotel. It is unique in that the hotel is part of the DuPont Building and not a separate structure. The modern equipment in the hotel rooms included baths or showers, electric fans, automatic fire alarms, a mail in office signal, and a telephone. There were 150 rooms in 1913 and over the years rooms were added to total 315 by 1963. The Hotel du Pont favorably impressed the 25,000 people who thronged the hotel that January day. Since then the hotel has established itself as a first-class hotel. From 1927 to 1933 the management of the hotel, the Bowman-Biltmore chain, changed the name to the Hotel du Pont-Biltmore, but the management of DuPont's General Service Department changed it back.

The Hotel du Pont lobby was impressive with its unique architecture and decor. The ceiling was of 14-carat gold leaf, making it look like a great hall of a Venetian palace. The structure was of genuine travertine, an Italian stone of soft coloring and texture, and all the woodwork, including the massive carved doors, is of American walnut. The original lobby and registration desk were located in what became the DuPont soda shop and real estate office. The Rose Room, or Ladies Lounge, was located where the present lobby stands. The revolving door caused delay in egress, so new safety glass doors were installed in the 1960s to separate the sitting area from traffic. The gold ceiling has been maintained and accented with teal blue and vermilion, and the carpeting is of a matching blue made with DuPont nylon. (Author's Collection.)

From the foyer of the ballroom a marble staircase with a balustrade of steel and bronze leads to the Du Barry Room, a banquet hall. The elements of white pilaster and walnut doors recreate American colonial architecture. The view shown here was taken during the time the Bowman-Biltmore chain operated the hotel.

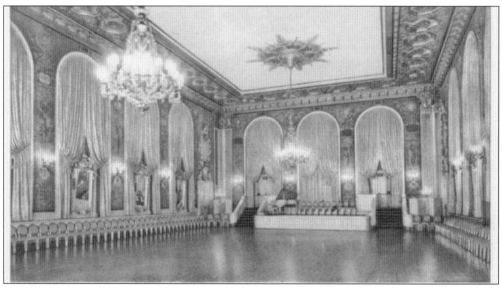

Directly off the lobby is the Gold Ballroom, which was constructed in the fifth section of the DuPont Building in 1918. The ballroom was originally on the eleventh floor. In 1919, when the fifth section was completed, the main entrance and lobby were transferred to their present location facing Eleventh Street and the Gold Ballroom was relocated to Eleventh and Orange Streets. The Gold Ballroom, designed by Raymond Hood, is in the style of Louis XIV and has walls of sgraffito, a process of colored plasters, and an elaborate ceiling. Thirty workmen were brought over from Italy and spent almost a year executing the sgraffito process. There are 16 arched windows with nylon drapes that are 27 feet long with an area of 170 square feet.

The nylon suite, a deluxe suite furnished throughout in nylon, was available to hotel guests ten years after the discovery of nylon. Window curtains, draperies, upholstery, carpeting, blankets, nylon-covered pillows, and bedspreads are all of nylon and are all found in this suite. Even the lampshades contain nylon, as well as the shower curtain, and towels. The nylon suite included a foyer, living room, bedroom, and two baths. The suite, announced to the press in December 1948, was decorated by Joanne Seybold, the decoration consultant of the hotel. A color scheme of green and rose was used for the living area and green and gold was used for the bedroom. Nylon was discovered by Wallace Carothers and his team at the DuPont Company's Experimental Station in 1937, and was announced in 1938. Nylon is amazingly resistant to abrasion, moths are not attracted to it, and it does not shrink.

The Brandywine Room of the Hotel du Pont, originally known as Peacock Alley, was used as a writing area when the hotel opened. It led to the Club Room and was used as a cocktail lounge. The Brandywine Room, the Club Room, and bar were done in Italian walnut, and in 1945, a circular leaded-glass decoration depicting a battleship hung over the ample fireplace. The Brandywine Room, which is smaller and more exclusive than the main dining room, the Green Room, was described in a DuPont Company in-house publication as a "combination of moderate gayety and pleasant restraint." (Courtesy of the University of Delaware Special Collections.)

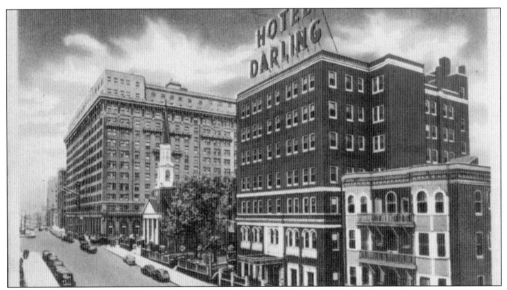

A competing hotel called the Hotel Darling was a red-brick structure located on Market Street between Eleventh and Twelfth Streets opposite the Federal Building and next to the Wilmington Club, an exclusive businessmen's club. After the war, people started moving to the suburbs and businesses followed. Suffering declining patronage, the hotel closed its doors soon after. (Courtesy of the University of Delaware Special Collections.)

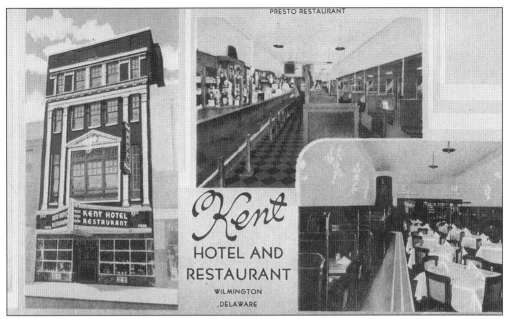

The Kent Hotel and Restaurant operated in the 700 block of Market Street near to where the Majestic Movie Theater stood. The hotel offered two restaurants, the formal Kent Restaurant and the casual Presto Restaurant and bar. The hotel sported a marquee similar to the movie theater's marquees. The hotel eventually succumbed to declining visitation and closed it doors in the 1950s. (Courtesy of the University of Delaware Special Collections.)

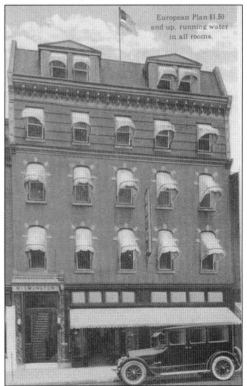

Another hotel on Market Street, which dates back to the early part of the century, was the Hotel Wilmington on the west side of the street on the 800 block. This card, sent in 1922, states that the Hotel Wilmington offered the European plan at $1.50 and up, which usually meant patrons received breakfast with their room. The hotel also promoted the fact that it had running water in every room. Mr. T. Thomas was the proprietor in the 1920s. By then the Grand Opera House had lost its musical and theatrical clientele, and the hotel began losing patronage.

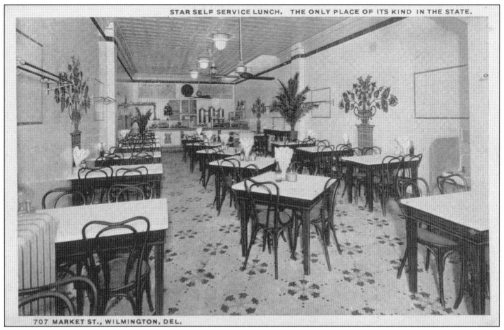

STAR SELF SERVICE LUNCH. THE ONLY PLACE OF ITS KIND IN THE STATE.

707 MARKET ST., WILMINGTON, DEL.

Typical of the restaurants on Market Street after World War II, the rooms were long and narrow. The Star Self Service Lunch, which bills itself as "The Only Place of its Kind in the State" served the businessmen, bankers, lawyers, and retailers lunch at its cafeteria at 707 Market Street by the W.T. Grant and Company store on the west side of Market Street.

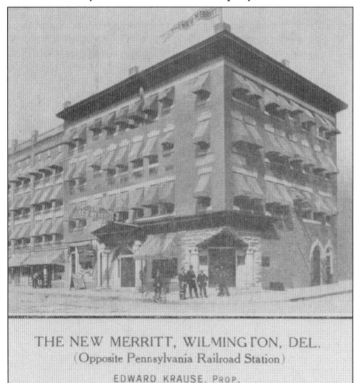

THE NEW MERRITT, WILMINGTON, DEL.
(Opposite Pennsylvania Railroad Station)

EDWARD KRAUSE, PROP.

The New Merritt hotel served the traveling public at its location opposite the Pennsylvania Railroad Station on Front Street. The train station was built in 1906 by well-know architect Frank Furness, but the view as one got off the train was less than grand. The Merritt was one of two second-class hotels serving this area, the other hotel was the Stoeckle. Both offered steam heat, electric lights, and café-style restaurants. The proprietor of the Merritt, printed on this card, is Edward Krause.

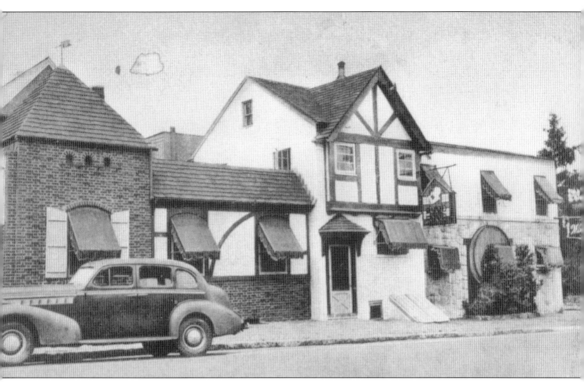

A local German brewery operated by Joseph Stoeckle stood at Fifth and Adams beginning in 1871 in the heart of the German community. Mr. Stoeckle also ran a second-class hotel by the train station on Front Street as well as a restaurant called Winkler's at Tenth and Shipley in 1910. Winkler's Restaurant and Tavern moved to Sixteenth and French Streets, where it remained well into the 1960s. (Courtesy of the University of Delaware Special Collections.)

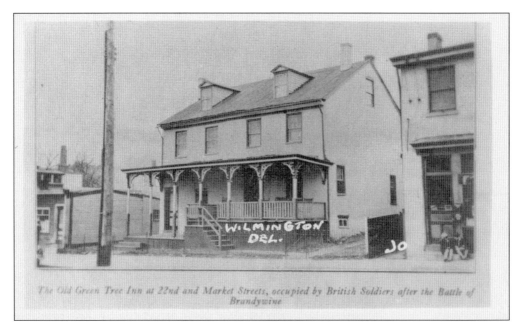

The Old Green Tree Inn at 22nd and Market Streets, occupied by British Soldiers after the Battle of Brandywine

The Green Tree Inn on Market Street near Twenty-second Street dated back to the American Revolution were it was alleged that British soldiers occupied it after the Battle of the Brandywine in 1777. This inn was close to Brandywine Village and Joseph Tatnall's flour mills, which the British tried to close down. Brandywine Village coopers were frequent visitors to this inn. The Green Tree Inn was on the property of Market Street and Concord Avenue in 1857 when it was torn down to make way for St. John's Episcopal Church.

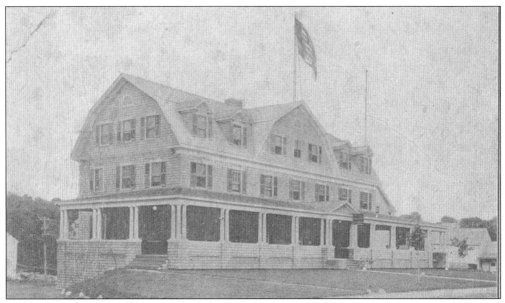

Childs' Tavern has not been in any local street directories. There were many local taverns in the city and surrounding communities before Prohibition sent them underground. This tavern may have been one of them. There was a Childs' Grocery at 621 King Street and 525 Madison Street and perhaps they are related.

Four

SHIPS, TRAINS, AND INDUSTRY

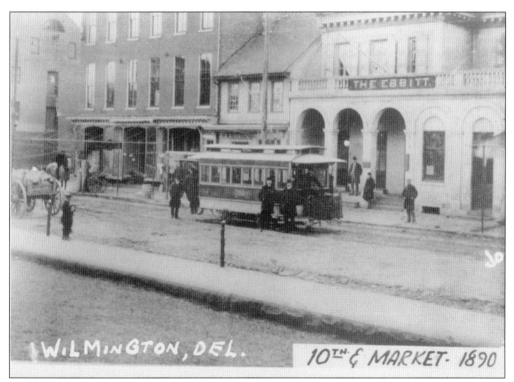

WILMINGTON, DEL.

10ᵀᴴ & MARKET- 1890

Joshua T. Heald, who had track laid up Market Street from Front to Tenth Streets and out Delaware Avenue, founded the Wilmington City Railway Company in the 1860s. The site of this 1890s view was taken at Tenth and Market Streets where the first section of the DuPont Company would be erected in 1907. The corner building was the Harkness Building and the Ebbitt Hotel was next door. The creation of the electric trolley effected the business center along Market Street and the growth of the city to the west.

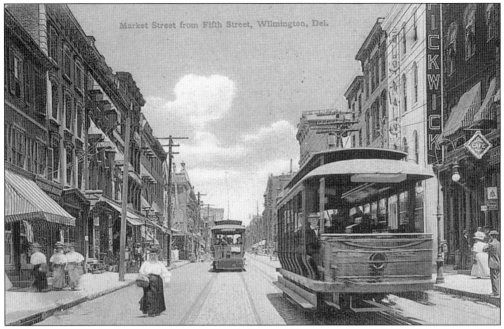

This 1910 view of Wilmington looking north from Fifth Street shows the prominence of the street car line in the retail district. The Clayton House, a first-class hotel on the northeast corner of Fifth Street, became the site of the luxurious movie palace the Queen in 1916. At 504 Market Street was the Pickwick Movie Theater, which operated from 1908 to 1919.

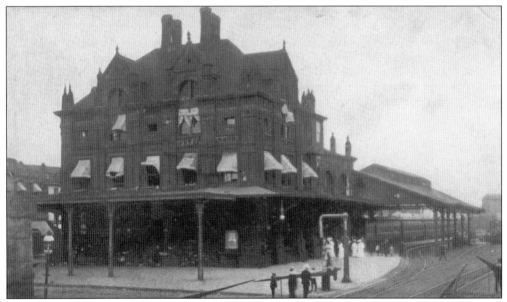

The Philadelphia, Wilmington, and Baltimore Railroad was a presence along the Christina River since the 1830s. Its tracks followed the curve of the river. In 1881 the Pennsylvania Railroad gained control of the PW&B and constructed an elaborate new station at Front and King Streets. The railroad tracks at this time were street level with only a single wooden arm in place to keep people off the tracks.

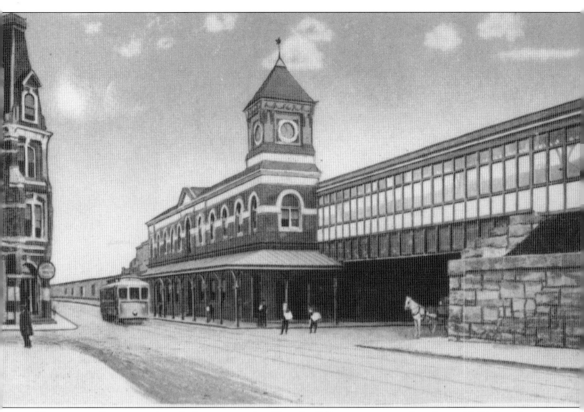

The Pennsylvania Railroad Station and office building was completed in 1907 by the Pennsylvania Railroad's Philadelphia, Baltimore, and Washington subsidiary. Frank Furness and his Philadelphia architectural firm, Furness, Evans, and Company, designed the station in 1905 to accommodate the elevation of the train tracks through Wilmington. Furness designed the station and office building to reside as one unit in a five-story brick and terra cotta building with a covered walkway connecting the station and office building. The building was referred to as one of "neatness and beauty."

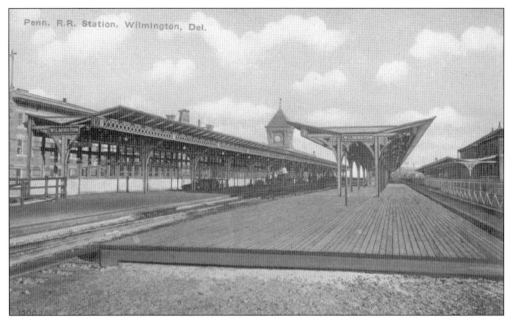

To accompany the new Pennsylvania Railroad Station and the elevated tracks, raised platforms with covered walkways became part of the Furness design of the depot. The elevated tracks were constructed in large part by the Italian immigrant population moving into Wilmington between 1903 and 1904. The elevation of the tracks, which still followed the curve of the Christina River, placed them between the depot and office building. The Pennsylvania Railroad electrified its train line by 1935. The Romanesque-style station made the surroundings on Front, Market, and King Streets look shabby in comparison. The station has since been placed on the National Register of Historic Places.

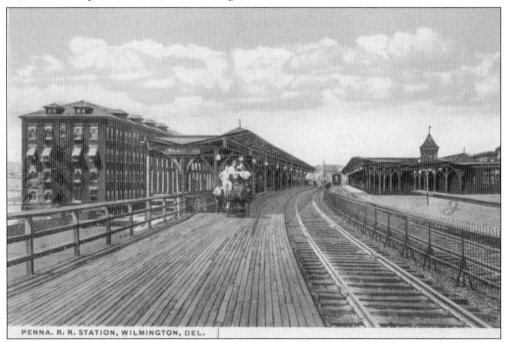

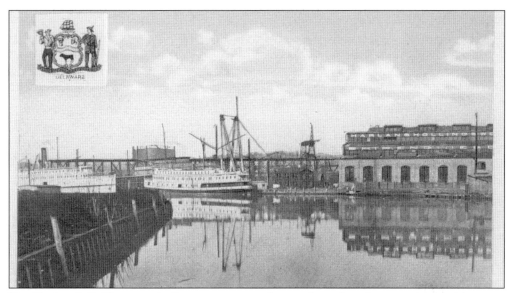

The Harlan & Hollingsworth Company, a manufactory for railroad cars and iron ships, was founded by Mahlon Betts, Samuel N. Pusey, Samuel Harlan, and Elijah Hollingsworth, who were machinists in the 1840s. J. Taylor Gause became its president in the 1860s. This firm constructed over 230 ships by 1887 and produced 300 railroad cars annually. By 1898 it had become Wilmington's largest industrial firm spreading along 3,000 feet of the riverfront and 76 acres of land. It had the largest capacity masting shears in the United States, 4 building ways, 11 derricks, a huge dry-dock, 4 lumber sheds, foundries, joiner shops, a large pattern loft, 5 car-erecting shops, and 7.5 miles of track with electric locomotives.

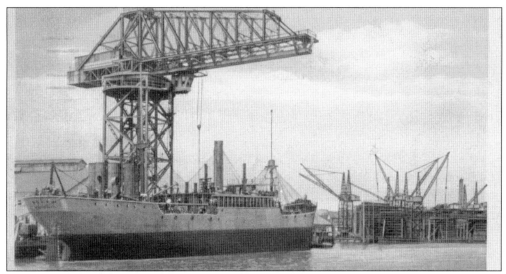

By 1901 Harlan & Hollingsworth became part of Bethlehem Steel of Coatesville, Pennsylvania, and the production of ships and railroad cars declined. The shipyard and lumber sheds were sold to the Dravo Corporation in 1926, and during World War II, the Navy had over 50 buildings with new shipbuilding ways and cranes built for Dravo, allowing for the construction of over 200 vessels. By 1950 H&H closed shop and the 1912 office building with its classic pediment and stone pillars is one of the H&H survivors of its industrial past.

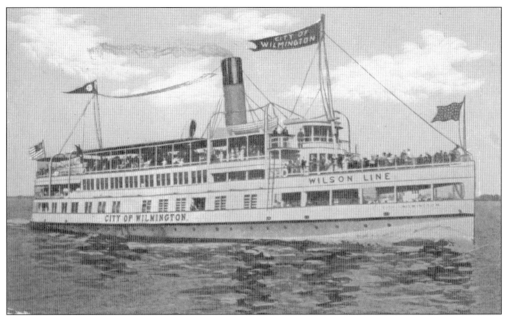

The Wilson Line, the main shipper on the Delaware River, was created by J. Shields Wilson, a shipbuilder who reactivated the Wilmington Steamboat Company in 1882. The Wilson Line, located at the foot of Fourth Street near the Pusey & Jones shipyard, carried freight in its early years, but became an excursion line as the railroad and trucks took over that business. The Harlan & Hollingsworth Company further south on the Christina River built this Wilson Line cruiser, *City of Wilmington*, in 1909.

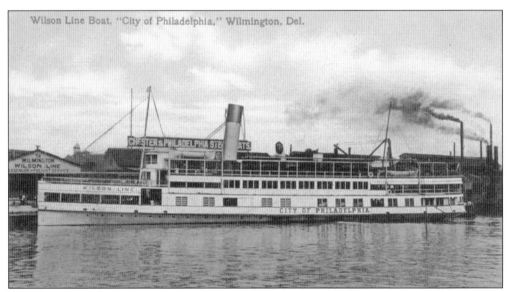

The Harlan & Hollingsworth Company built the *City of Philadelphia* at the same time it built the sister ship *City of Wilmington* for the Wilson Line in 1909. They were referred to as *Boat #1* and *Boat #2* before they were named. The Wilson Line ran regular excursions between Wilmington and Philadelphia and across the Delaware River to Riverview Beach in Penns Grove, New Jersey.

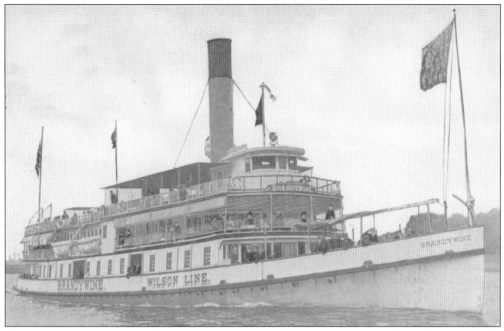

Harlan & Hollingsworth also built the *Brandywine* for the Wilson Line. This steamship was built in 1885 on a design by J. Shields Wilson. The *Brandywine* turned out to be the fastest propeller steamer on the Delaware and perhaps the fastest anywhere at the time. Because of her speed, she established the Wilson Line's importance on the Delaware River. The *Brandywine* also was used as an icebreaker because of her 1,000-horsepower engine. She was retired in 1952.

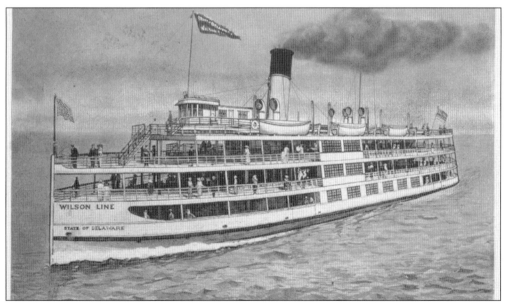

The *State of Delaware* was another cruise ship built for the Wilson Line by the Harlan & Hollingsworth Company. The Wilson Line needed bigger steamships as the popularity of excursions between Wilmington and Philadelphia and across to Riverview Beach grew.

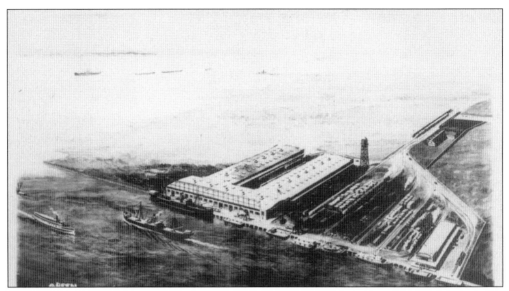

The Wilmington Marine Terminal, built at the confluence of the Christina River and the Delaware, was completed in 1923 at a cost to the city of over $3 million. The contractor for the construction was the DuPont Construction Company, a subsidiary of the DuPont Company. They built four storage sheds and room to unload three ships of 7,500 tons simultaneously along 5,000 feet on the Christiana and 2,000 feet on the Delaware. Once this project was finished, the city's attention focused on highway development.

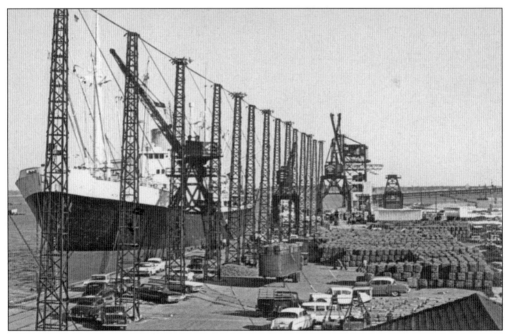

In the 1990s the Wilmington Marine Terminal underwent a name change to the Port of Wilmington. The Port has grown tremendously since 1923 and contributes significantly to Wilmington's economy. Chief imports include lumber, meat, bananas, and foreign made automobiles.

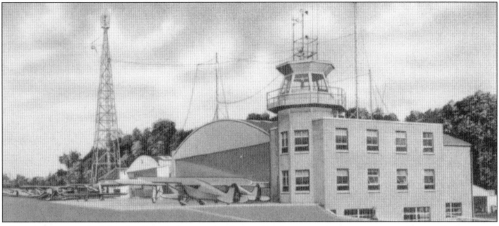

The DuPont Airfield, which was located where the DuPont Company's Barley Mill Plaza sits today on Routes 141 and 48, was founded by aviation enthusiast Henry Belin du Pont in 1927. Later names for this airfield were Du Pont Airport and Atlantic Aviation Service. This airport served an important role during World War II by allowing airplanes carrying war supplies to land and take off. The Atlantic Aviation Service, a commuter and cargo service, was based at this airport. Competition from the New Castle County Airport forced du Pont to close the airport down in the 1950s. (Courtesy of the Historical Society of Delaware.)

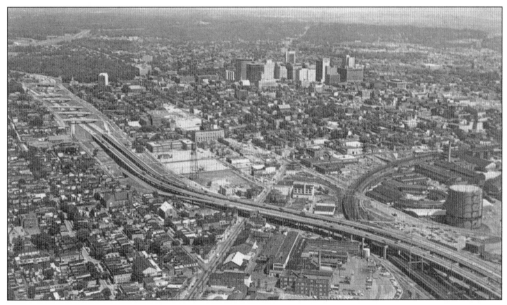

On July 2, 1924, the DuPont Highway (Route 13), which ran over 100 miles of the State of Delaware, was declared opened by its benefactor, Thomas Coleman du Pont, president of the DuPont Company from 1902 until 1914. His initial proposal was wrought with fierce opposition, but the man with the money was able to get the highway built. Not since then has there been such controversy over a highway as over the building of the interstate, I-95, splitting Wilmington in half at Adams and Jackson Streets. The civic plan was expected to draw people into the city because it would be easier to get in and out. It had the opposite effect when it initially opened in September 1968. For better or for worse, the interstate has become an important artery connecting Wilmington with Baltimore and Philadelphia.

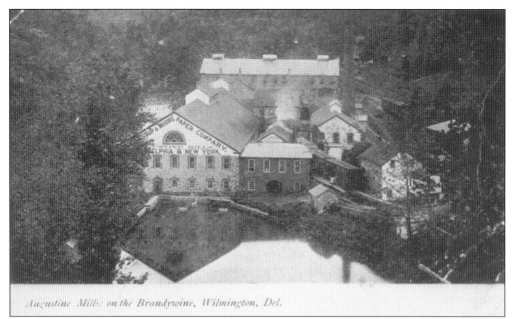

Augustine Mills on the Brandywine, Wilmington, Del.

The Augustine Paper Mills began operation in 1845 when Bloomfield H. Moore and his father-in-law, Augustus E. Jessup, teamed up to establish the paper-making firm of Jessup and Moore. The Augustine Mill was an old snuff and flourmill on the Brandywine River, which Jessup and Moore adapted to the manufacture of paper, including heavy iron and stone construction to make the building fireproof. Their business was so successful that it eventually dominated the paper-making business along the river. The mill still produces sheet brown paper from recycled boxes and is located on the north side of Brandywine Park below the Augustine Bridge. (Courtesy of the Hagley Museum and Library.)

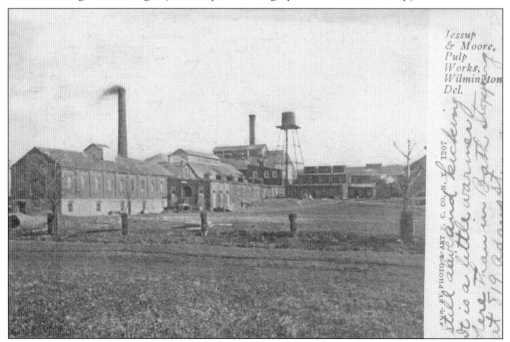

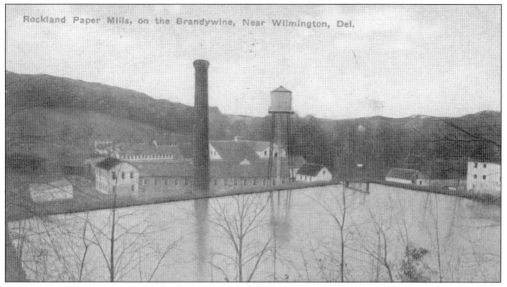

The Rockland Paper Mills were located on both sides of the Brandywine River north of the DuPont Gunpowder Works. William Young operated a paper mill in 1810 on the north side of the river. In 1856 Jessup & Moore, who had started their paper-making business at the Augustine Mill, purchased the property and converted the mills to produce high-quality book paper. They rebuilt after an 1867 fire, adding brick and iron structures to the older stone buildings and installing the first Pusey & Jones Fourdrinier machine. These mills ceased operation early in the 20th century and the site is presently a residential enclave.

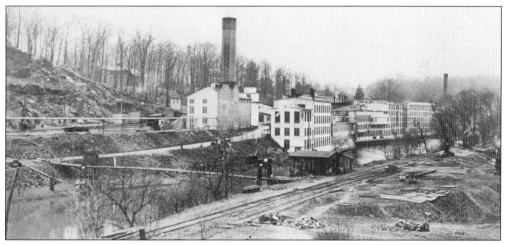

The manufacturing of textiles was the domain of the Joseph Bancroft & Sons Company on the south side of the Brandywine River between the DuPont Gunpowder Works and the Augustine Mills. Joseph Bancroft, a foreman at the Rockland Paper Mills of William Young, purchased property from the Rockford Manufacturing Company, which included an unused mill, dam, houses, and barn. Bancroft installed hand mules, 1,500 spindles, and looms. After a fire in 1839, Bancroft rebuilt and his business grew so rapidly that he introduced new technologies such as bleaching and finishing to compete. Bancroft Mills eventually included the Kentmere Mills. Bancroft Mills continued doing business into the 1950s, but was sold in 1961 to Indian Head Mills.

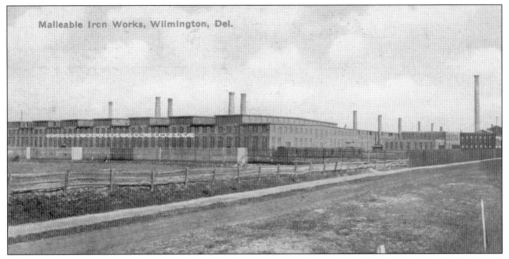

Wilmington's larger industrial firms had their own foundries, but iron work for local construction was produced by the Malleable Iron Works, which was formed at Taylor and Buttonwood Streets in 1881. This iron works, called Wilmington Malleable Iron Works, covered an area of 6,500 feet and contained two engines equaling 80 horsepower. By 1890 the capacity of production was about 40 tons of casting a week. A depression in the 1870s kept strikes at industrial sites at bay, but by 1878 they were common. A strike at the Malleable Iron Works in 1885 over the company's policy forbidding its workers to socialize before work was unsuccessful because the workers needed the money. The Delaware Malleable Iron Works, which grew out of this concern, built a large factory on the Delaware River near the Christina River in 1903.

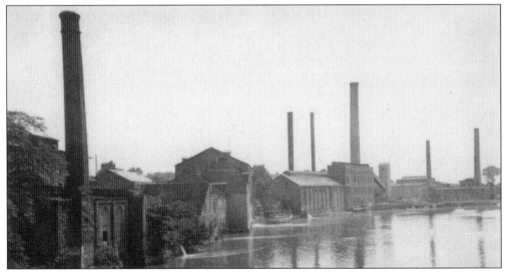

The Tatnall and Lea Mills, known as the Brandywine Mills, operated until the 1930s when a fire destroyed the flour milling business. Joseph Tatnall built these mills in the 1770s on the Brandywine River at Eighteenth and Market Streets. His son-in-law, Thomas Lea, took over the mills, and they remained in his family. As part of a revitalization of the milling area, which borders Brandywine Village where Joseph Tatnall lived, the Lea Mills were converted into condominiums in the 1980s. (Courtesy of the Hagley Museum and Library.)

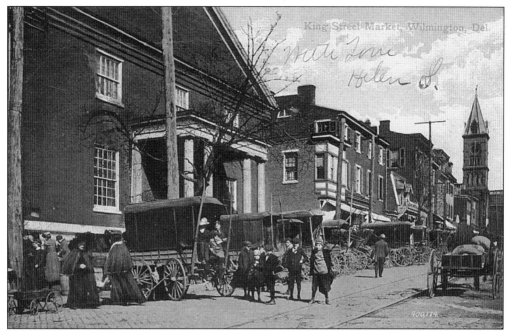

King Street became the farmers' street market after 1864 when a decision was made to move the street market from Market Street to allow for the trolley tracks. The street markets ran from Third Street up to Tenth Street and on market days, which originally occurred on Wednesdays and Saturdays, and then were on Tuesdays and Fridays. Market days would draw up to 300 vendors. The wagons and later the cars had to be backed up to the curb and the produce and wares were displayed on benches. Retail stores began filling the blocks between Third and Tenth on King Street, which by 1880 totaled around 120 stores offering everything from live chickens, to housewares, to clothing. By this time city law dictated that farmers could only sell produce. The street markets on King Street were virtually non-existent by the 1960s, but its 100-year history is a story of nostalgia.

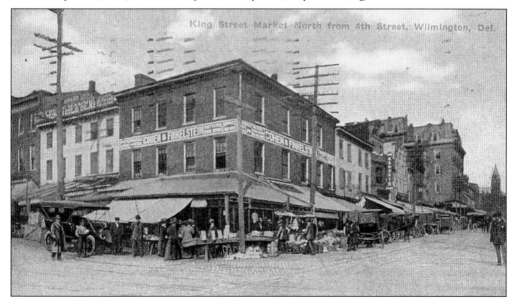

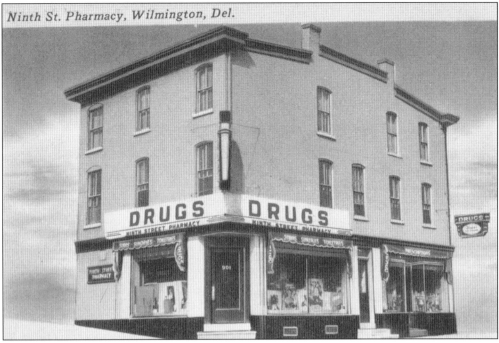

Ninth St. Pharmacy, Wilmington, Del.

The Ninth Street Pharmacy opened at 901 French Street in 1940 and remained in operation until 1965. Mr. A. Roland Millburn was the manager for many years. This type of retail business, the "drug store," was a sign of prosperity, being a gathering place, as well as a local store to get one's cures. It stood on the block behind Millers Furniture store. (Courtesy of the University of Delaware Special Collections.)

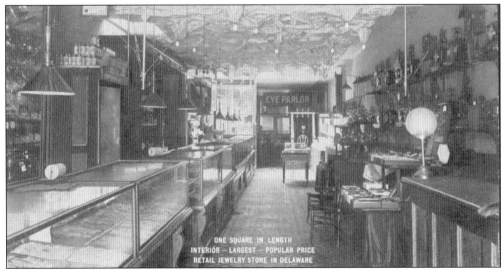

Another type of specialty retail store that opened on Market Street was the jewelry store. The Lyn Thomas Company was established at 409 Market Street by 1910 and advertised the store as the largest retail store in Delaware. A Philadelphia jeweler, J.E. Caldwell, opened a branch store in the Hotel du Pont in 1953, and by then Lyn Thomas' store had disappeared from Market Street.

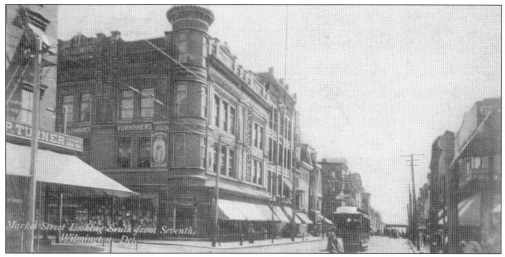

N. Snellenberg and Company, a men's and boy's clothing store, was located at the southeast corner of Seventh and Market Streets by 1900, but disappeared by 1932. They had a distributor's station at 207 Vandever Avenue from 1932 to 1938. David Snellenberg was store manager in the 1920s. The Depression of the 1930s hurt retail businesses and Snellenberg's could not survive the Depression coupled with competition from James T. Mullin's men's and boy's outfitters down the street.

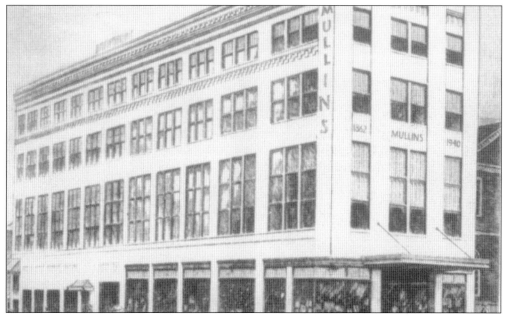

James T. Mullin ran a men's and boy's clothing store in West Chester, Pennsylvania, that opened in 1865. By 1878 Mullin and Sons had moved the store to Wilmington at the southeast corner of Sixth and Market Streets. Mullin was glad to have access to the railroad line here, which gave them direct access to supplies and fashions. The influx of business people and clerks to the city kept Mullin's so busy that he expanded the store in 1917. Mullin's remained a fixture on Market Street until 1974. The building is currently being used for apartments. (Courtesy of the Historical Society of Delaware.)

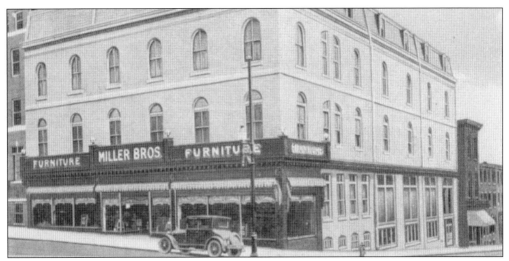

Miller Brothers Company was opened in 1926 at the northeast corner of Ninth and King Streets and stood next to the YWCA building until that building closed. Miller's staff included Nathan Miller (president), Frank M. Clough (secretary), and Robert A. Shaw (treasurer). They sold furniture, rugs, carpets, and stoves. Their advertisement in the street directory said "Wilmington's largest furniture store." Miller Brothers closed in the 1970s and moved up to Route 202. (Courtesy of the University of Delaware Special Collections.)

The John Wanamaker branch store was built on the hill north of the Augustine Bridge at Eighteenth Street between 1949 and 1951. The store was built by Philadelphia-based general contractor John McShain, who is known for building the Pentagon, the Jefferson Memorial, and restoring the White House. The main Wanamaker store is in Philadelphia, and the Wilmington store was a tribute to it in size, with over 3 million cubic feet of space. The local architectural firm of Massena & du Pont, Inc. were involved in this project. The store's golden eagle stood facing out the main display window, and Wilmington residents were drawn away from downtown to shop. When the store closed in the late 1980s, Wilmington mourned its loss. (Courtesy of the Historical Society of Delaware.)

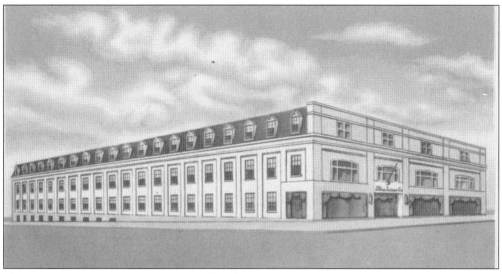

The J.B. Van Sciver Company was another furniture store on King Street. Van Sciver opened his store at 844 King Street in 1948, with Charles P. Maroney as manager. Within a few years he expanded to include 844 to 848 King Street. By 1971 Van Sciver's moved to Lea Boulevard and Governor Printz Boulevard, with R.K. Phifer as manager.

The United States was under prohibition from 1921 to 1933, when the amendment restricting the consumption of alcohol was repealed. Following that action, a huge liquor store was opened at 2300 Market Street under the name of the Delaware Liquor Store, Inc. The store served a wide community from Brandywine Village on north. This store was near the Strand Movie Theater, which was built at 2412 Market Street in 1920. (Courtesy of the University of Delaware Special Collections.)

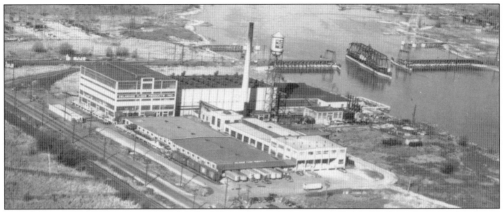

The Delaware Floor Products, Inc. operated a large manufactory along rail lines at 1001 Christina Avenue on the river beginning in the late 1920s. Their main products were floor coverings, but during World War II they produced a large amount of camouflage cloth for the military. This business flourished into the 1950s. The president of the company was Walter Bender.

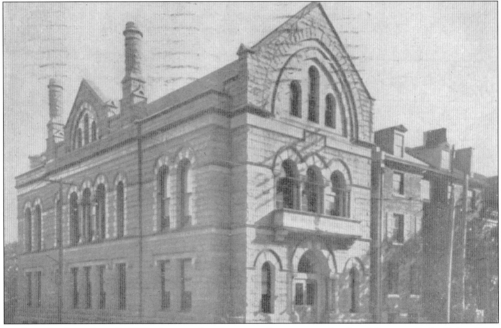

Within the last decade Wilmington has become known as the banking capital of the Mid-Atlantic. Truly, Wilmington's banking laws are favorable to incoming banks, but in the 19th century banks also flourished. Wilmington's prominent citizens organized the Wilmington Savings Fund Society, one of Wilmington's oldest banks, in 1831, and the society was incorporated in 1832. The WSFS opened for business on February 18, 1832, on Market Street between Fifth and Sixth Streets. By 1906 the society's assets grew to over $7 million. In 1856 the society erected an iron-front building at the southeast corner of Eighth and Market Streets, and in 1887, it moved to the southeast corner of Ninth and Market, catty-corner to the Equitable Guarantee and Trust Company, where it has remained. WSFS branches have sprouted all over the city.

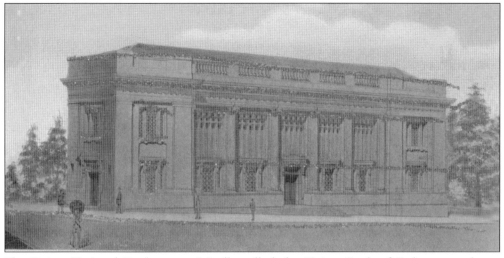

The Union National Bank was originally called the Union Bank of Delaware and was chartered as a state institution in February 1839. It opened for business in May 1839 at its building at Eighth and Market Streets. Wilmington industrialists, such as James Price, Edward Tatnall, James Canby, William Lea, and Alfred V. du Pont were elected to its board of directors. In 1865 the bank converted to a national bank, seeking the advantages of the national banking system. In 1873 a brownstone front was added to their building.

The Artisans Savings Bank was Wilmington's second savings institution opening for business at 117 Market Street in April 1861. The bank moved two times before settling at 505 Market Street opposite the Clayton House in 1873. The bank continued to operate at that site until it moved out in 1960, at which time it became the library of the Historical Society of Delaware. Artisans Savings Bank has the distinction of settling away from the city's other banks clustered between Eighth and Tenth Streets on Market Street. (Courtesy of the University of Delaware Special Collections.)

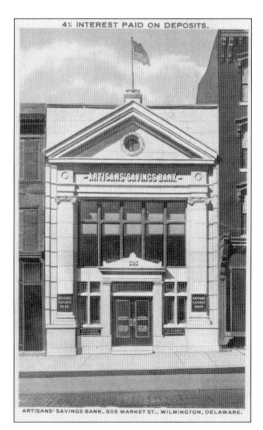

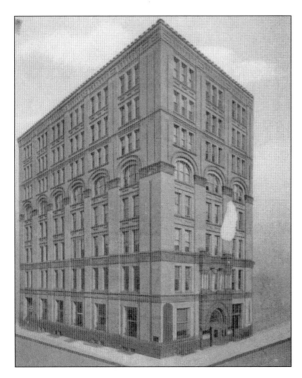

The Equitable Guarantee and Trust Company, incorporated in 1889, had a six-story building constructed for their offices at the northwest corner of Ninth and Market Streets in 1892 at a cost of $200,000. It was Wilmington's first skyscraper, even though it became dwarfed by the 12-story DuPont Building erected across the street in 1907. Many early views of Wilmington come from photographers who stood at the top of the Equitable. The site of the Equitable Guarantee and Trust Company has remained constant in the banking industry. (Author's Collection.)

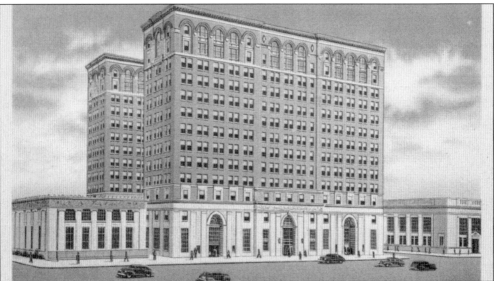

The Delaware Trust Building was Alfred I. du Pont's bank constructed behind the Wilmington Institute Free Library in 1922. His cousins, Pierre S. du Pont and T. Coleman du Pont, established their own bank, the Wilmington Trust Company. So, in rivalry, Alfred built his nearby. He had it constructed at a time and location that would interfere with Pierre S. du Pont's project, the Wilmington Institute. The institute's blueprints had to be altered and construction delayed to accommodate Alfred's Delaware Trust Building. Aside from the controversy, the Delaware Trust Building is very much a part of Wilmington's skyline at Rodney Square.

Five

SCENIC ROUTES

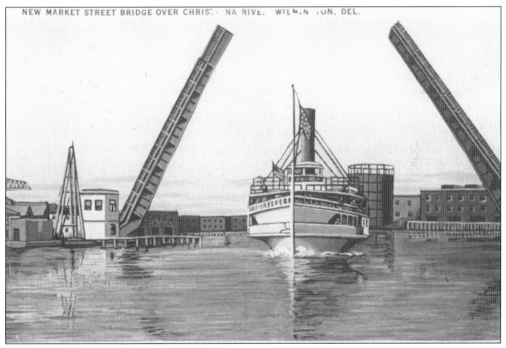

NEW MARKET STREET BRIDGE OVER CHRIST. NA RIVE. WILM.N ;UN, DEL.

In the 21st century travelers enter the city from the south by crossing the Walnut Street Bridge over the Christina River and leave the city by using the Market Street Bridge over the same river. The Christina River had heavy river traffic in the first half of the 20th century due to the Harlan & Hollingsworth shipbuilding firm, Pusey & Jones shipbuilding, and the Wilson Line cruise ships. To accommodate this traffic a new drawbridge was built over the Christina in the 1930s. The Du Pont Highway (Route 13) was completed in 1924, bringing more automobile traffic across the river. The new bridge was more substantial to allow for the heavier vehicular traffic.

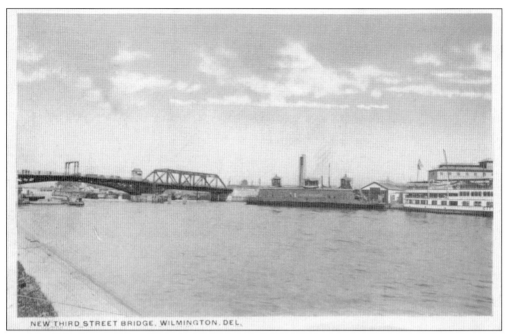

NEW THIRD STREET BRIDGE, WILMINGTON, DEL.

Further up the Christina River, the Third Street Bridge, a Pratt through truss bridge, crosses and connects wards two and four of the city. In this view the steamers of the Wilson Line whose docks were at the end of Fourth Street can be seen. The Third Street Bridge is now a cement-arched bridge.

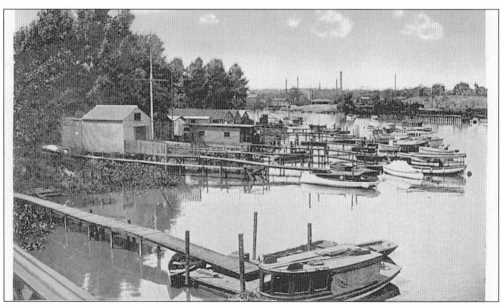

This view is of the Brandywine River looking south from the Eleventh Street Bridge about 1915. Obvious are all the pleasure craft, which plied the Brandywine for fishing and relaxation. The landing is called the Orchard, and people would dock here and picnic. The farmers had a much different view, bringing their grain to the flour mills at Market Street in the 1800s.

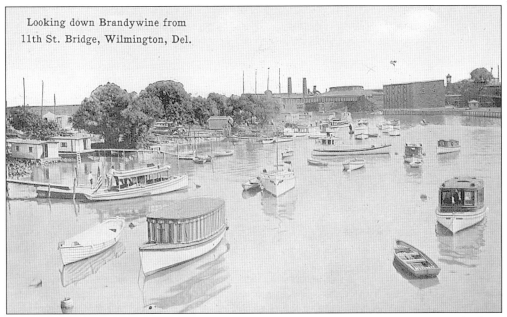

Looking down Brandywine from
11th St. Bridge, Wilmington, Del.

This is a view from the Eleventh Street Bridge over the Brandywine River in 1915 looking north. In this view are the huge brick flour mills started by Joseph Tatnall in 1770 and continued by his son-in-law, Thomas Lea, and his family. Rowboats and sailboats are docked at this juncture. The Brandywine River, once boasting a strong milling and industrial community on its shores, became less industrial after the shipbuilding firms and foundries located along the shores of the Christina.

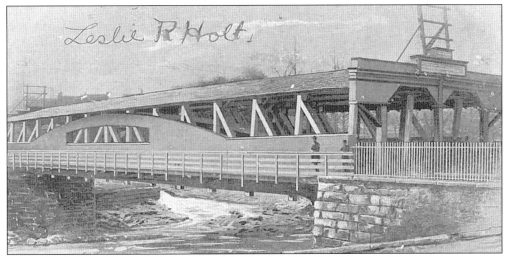

The first covered wooden bridge over the Brandywine River was the State Bridge #575 (North Market Street Bridge), built in 1822. It was a double-span, timber Burr arched truss bridge, 145 feet long and 28 feet wide, and costing about $7,500. This bridge was washed away in 1839 by a flood and was replaced by a second covered bridge by eminent bridge builder Lewis Wernwag. The arches of this bridge were particularly heavy and the portals were ornate. The sidewalks of this bridge were covered overhead, but the side coverings were open. The bridge was replaced in 1887 by an iron and steel Pratt through truss bridge.

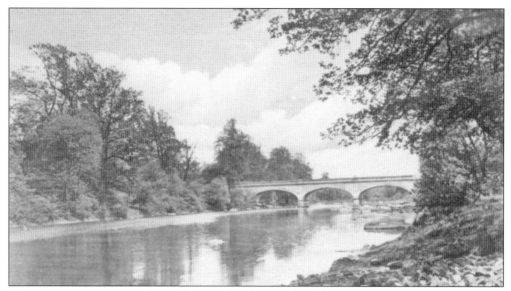

The Van Buren Street Bridge is the next bridge north of the North Market Street Bridge. It is made of reinforced concrete connecting the north and south side of Brandywine Park at Josephine Gardens. This bridge served as an aqueduct from its construction in 1906 until the mid-1990s, carrying water from the Porter Reservoir to the Cool Springs Reservoir at Tenth and Franklin Streets. Theodore A. Leisen, a civil engineer with the Wilmington Water Commission in 1906, coordinated the city's need for a new water main and the Wilmington Park Commissioners desire for another bridge across the Brandywine by having the Van Buren Street built as an aqueduct. By the 1990s, traffic, water leaks, and age began undermining the bridge. In 1997 the Delaware Department of Transportation, with input from the State Historic Preservation Office and community groups including the Friends Society of Brandywine Park, restored and reinforced the bridge. (Courtesy of the Hagley Museum and Library.)

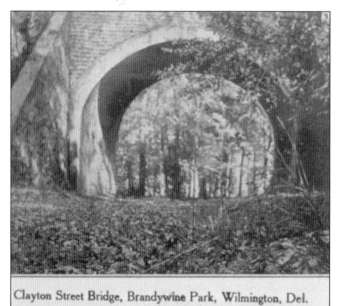

Clayton Street Bridge, Brandywine Park, Wilmington, Del.

The Clayton Street bridge does not cross the Brandywine River but crosses the dry bed of Rattlesnake Run, which once was its tributary, as the stream so appears on Wilmington maps for 1876. The stream bed runs from Gilpin Avenue at Clayton Street, while the stone bridge above carries Lovering Avenue across the dry bed. This area is currently being landscaped to stop the heavy erosion. (Courtesy of the Hagley Museum and Library.)

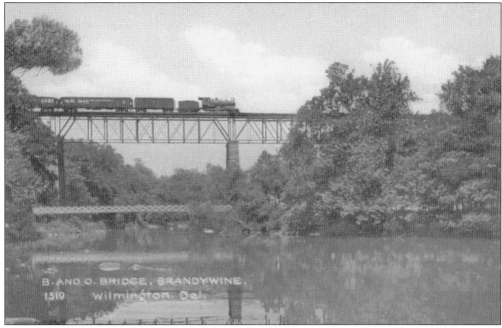

The Baltimore & Ohio Railroad built this iron bridge in 1885 as part of its Philadelphia-to-Baltimore line. It is a pin-connected Pratt-type deck truss, nearly 1,000 feet long and 110 feet above the Brandywine, supported by five piers made of stone from the quarry of John Riddle Sons & Company. In 1920 the bridge was purchased by New Castle County and was converted into a highway bridge, the Augustine Bridge, which is currently in use. (Author's Collection.)

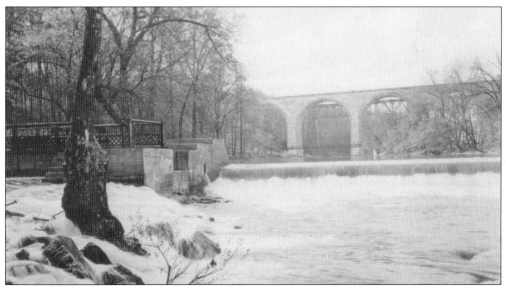

The Baltimore & Ohio Railroad built an iron-truss span across the Brandywine River in the late 1800s. This bridge could not support heavier locomotives, so by 1910, it was replaced by a seven stone arched span, built of composite masonry and with a sandstone face on a foundation of Brandywine granite. (Courtesy of the Hagley Museum and Library.)

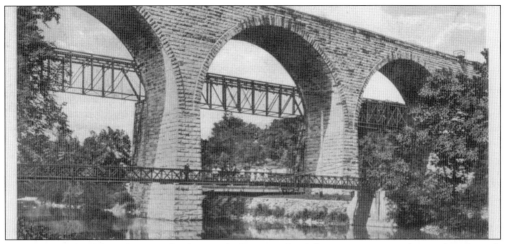

The B&O Railroad Bridge stands about 140 feet south of the Augustine Bridge and its length is 764 feet. There are three stone arches of 1,000 feet and two each of 90 feet and 80 feet. It was constructed in 1910 by the Charles A. Sims & Company of Philadelphia and has remained in use since that time.

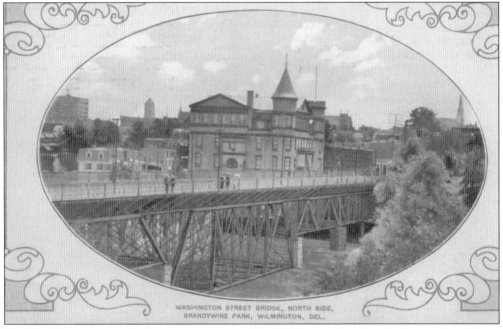

WASHINGTON STREET BRIDGE, NORTH SIDE,
BRANDYWINE PARK, WILMINGTON, DEL.

The Washington Street Bridge was constructed in 1893 by the New Castle County Levy Court at the behest of the North Side Improvement Company, a real estate firm headed by local businessman, Samuel Baynard. The bridge stretched across the Brandywine River to where the Washington School (School No. 24) and the Delaware Hospital stood and remain today. Baynard and his colleagues purchased land on the north side of the Brandywine, subdivided it into lots, and began marketing the lots as part of a development called Washington Heights. The Washington Street Bridge provided the necessary access to this development. The bridge was a metal-truss type, and by 1918, it had to be replaced because it was too light to withstand the volume of traffic.

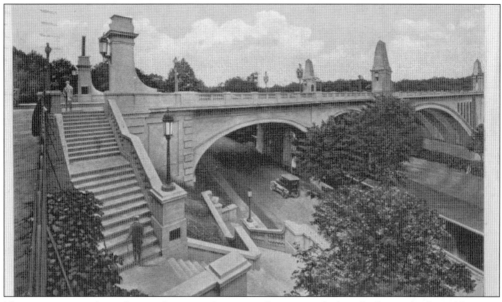

The move to replace the Washington Street Bridge coincided with the end of World War I. Sentiment grew among Wilmingtonians that the new bridge should be a war memorial for Delaware soldiers killed during the war. The Washington Street Bridge was closed in August 1920, and the new span opened to vehicular traffic in January 1922. The Washington Street Bridge Commission, charged with seeing the new span built, decided to change the name from the Washington Street Bridge to the Washington Memorial Bridge just in time for the formal dedication of the bridge on Memorial Day 1922. The names of the war dead are inscribed on tablets on the bridge. This five-arch concrete span was only one of many built as memorial bridges to dead soldiers across the country. The main span is 250 feet with two spans each of 70 feet and 85 feet, with the overall length being 720 feet. The arches are not solid, but consist of three large arched ribs for each section. Four massive stone pillars shaped like obelisks, ornate light fixtures, Greek urns and columns at the portal, and cut-stone handrails shaped like columns clearly identify this bridge as classical architecture. Benjamin Davis (engineer), Vance W. Torbert (architect), and the Walsh Construction Company were the contractors who worked with the commission on the bridge. On the southeast side of the bridge steps were built down to Brandywine Park.

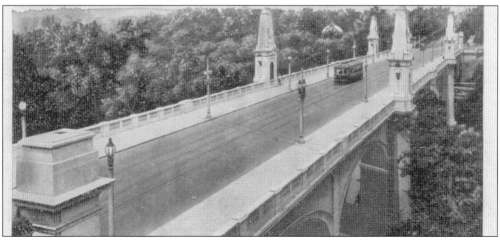

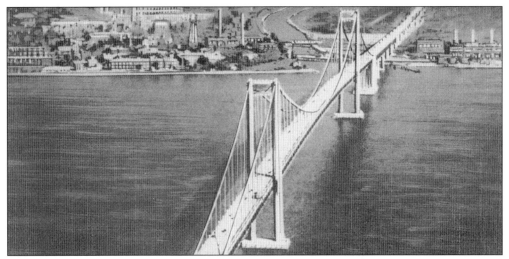

The farmers from New Jersey who came to Wilmington to sell their produce and wares at the street markets on King Street traveled by water transportation. By 1950 Wilmington's population was over 110,000. People were moving out to the suburbs and traveling more generally, and industries were expanding beyond the city limits. To accommodate the need for easier access across the Delaware River, the first span of the Delaware Memorial Bridge connecting Wilmington with Penn's Grove, New Jersey, was completed in 1951, three years after it was started. It is a suspension bridge and at the time of its opening it received the American Institute of Steel Construction's award for the most beautiful long-span bridge. The suspended section is 2,150 feet long with two 750-foot side spans, the total length being 10,507 feet. The towers are 440 feet high and carry 19 and 3/4-inch steel wire cables. Howard, Needles, Tammen, and Bergendorf designed the bridge with O.H. Ammann as a consultant and A. Gordon Lorimer as the consulting architect. The American Bridge Division of the U.S. Steel Corporation fabricated the structure. (Courtesy of the Historical Society of Delaware.)

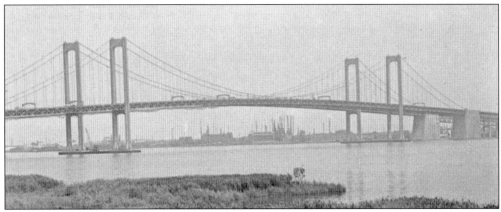

In 1964 construction was started on the second span of the Delaware Memorial Bridge and by 1969 it was opened. This span is of near-identical appearance to the first span and was designed by the same engineering firm with E. Lionel Paulo as the consulting engineer. The Bethlehem Steel Corporation and the Harris Structural Steel Company built this later bridge. This sister span was also awarded the American Institute of Steel Construction's award for a long-span bridge.

The movement for public parks began in the 1860s with real estate developer, Joshua T. Heald, who created the Wilmington City Railway and had tracks built out Delaware Avenue. He was afraid that the city's expansion would encroach on the wooded area of his real estate. U.S. Senator Thomas F. Bayard supported the move for parks, but the citizenry was less enthused. Parks again became a public issue in the 1880s with initiative from William P. Bancroft, son of textile industrialist, Joseph Bancroft. A park commission bill passed the state legislature and by 1895 the city boasted 252 square acres of parkland. Cool Spring Park at Tenth, Adams, and Van Buren Streets bordering the Cool Spring reservoir was one of these parks. The fishponds and tree shaded paths made this park particularly delightful. The park is still in existence, but the ponds are gone. (Author's Collection.)

The Wilmington Park Commission recognized that parks and playgrounds needed to be located in the densely populated area of the city, as well as outside of it. The Kirkwood Park was one of these small parks located on the city's east side, north of Seventh Street on Kirkwood Street just off Walnut Street. This small park provided an open space for recreation and relaxation.

Eden Park was once the site of Peter Bauduy's estate and powder manufactory located on the Christina River on Route 9 towards New Castle. Peter Bauduy is credited with building Wilmington's old town hall in 1797. He also helped E.I. du Pont establish his gunpowder works on the Brandywine, with Bauduy becoming du Pont's partner. This partnership dissolved in 1815 and Bauduy moved his family to the estate he purchased called Eden Park. Here he operated a rival powder manufactory. Eden Park is still a public park.

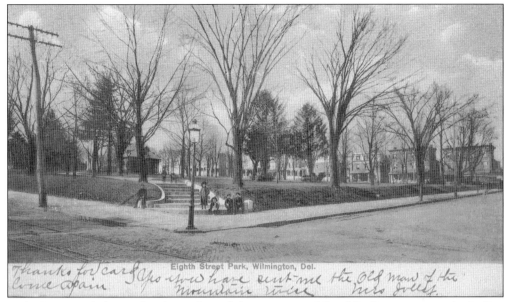

Eight Street Park, located at Seventh, Eighth, Broom, and Franklin Streets was in the Italian community known as Little Italy in a location known as the Hill. This residential area grew rapidly after the influx of Italian immigrants to the area in 1903 and 1904, and the park gave them an open space.

Brandywine Park came into existence largely because of William P. Bancroft, the first president of the Wilmington Board of Park Commissioners. After the effort to establish a park system in the city in the 1860s failed, Bancroft offered the city an 80-acre tract of land along the Brandywine in the 1880s, stipulating that the city add contiguous land and administer the park through a non-partisan commission. A park commission bill was drafted by prominent businessmen including Mayor John P. Wales, George H. Bates (attorney), Joshua T. Heald, William M. Canby (president of WSFS and a city councilman), Col. Henry A. du Pont, and J. Taylor Gause (president of Harlan & Hollingsworth). The bill passed the state legislature with ease. Frederick Law Olmsted, the creator of New York's Central Park, was invited to review the proposal for the Brandywine Park, and gave it an ecstatic review. This view is of the entrance to Brandywine Park taken from the south side of the North Market Street Bridge at Sixteenth Street. Soldiers' Park is no longer there.

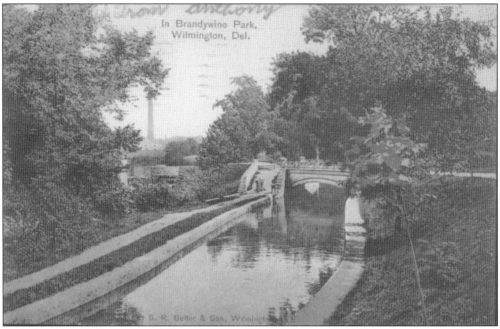

This is a view of Brandywine Park at its West Street entrance. The sluice gates at the head of the race can be seen in this image. These gates control the flow of water to the pumping station in the distance, but also control the amount of water in the race.

The race, constructed in 1900 of Brandywine granite, supplies water from a dam 4,800 feet upstream to the pumps at the Wilmington Pumping Station. There used to be a race on the north side of the Brandywine, as this picture shows, but it was discontinued and dismantled.

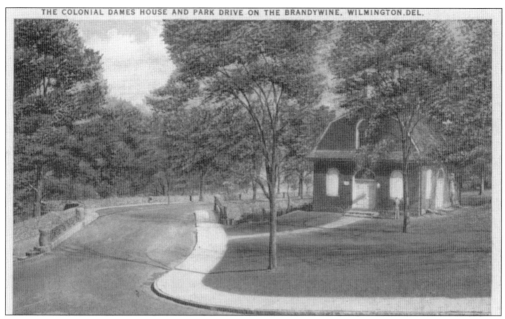

Continuing through Brandywine Park on Park Drive, the old First Presbyterian Meetinghouse, which was located on Market Street at Tenth Street and served for a time as the home of the Historical Society of Delaware, is found at the bottom of West Street. The Meetinghouse was moved in 1916 when the Wilmington Institute Free Library began construction at the Market Street site. It was moved to the park location, serving as the headquarters for the Colonial Dames.

Six dams are located between the end of the site of the DuPont Gunpowder Works and the tidewater end of the Brandywine River at North Market Street. This view is of the Third Dam, located just below Rattlesnake Run, and the B&O Railroad Bridge in Brandywine Park. These dams gave Brandywine its power, and its power is what drew so many millers and industrialists to its shores. The dam was constructed in the 1870s, and the sluice gates at this dam divert water to the race on its way to the Wilmington Pumping Station.

Josephine Gardens serves as a memorial to Josephine Tatnall Smith, who died in 1932. Her husband Col. J. Ernest Smith, a Wilmington lawyer, presented the city with the memorial fountain and two rows of Japanese cherry trees in 1933 to be located in Brandywine Park. The trees and fountain became known as Josephine Gardens and are located on the north side of Brandywine Park at Van Buren Street, the site of the annual Brandywine Arts Festival. The 26-foot fountain with its sculpture of a 5-foot, 8-inch female figure on top is modeled after a 16th-century fountain in Florence, Italy

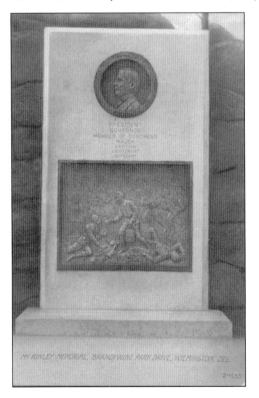

A memorial to William McKinley (1843–1901), 25th president of the United States, stands in Brandywine Park. McKinley served through the Civil War as a sergeant, captain, and major. He was a member of Congress from 1876 to 1891, and served as governor of Ohio in 1891 and 1893.

Brick row houses line Wawaset Street running parallel to Park Drive in Brandywine Park at Van Buren Street. The same location in the 21st century is nearly unchanged with the exception of a traffic light and the interstate overhead. This view of the park is around 1915. (Courtesy of the Hagley Museum and Library.)

This structure was known by several names, but when it was first completed in 1902 it was known as the Sugar Bowl. Theodore Leisen, the civil engineer for the Water Commission, proposed that the parks have open-air concerts and thus the elegant bandstand was built overlooking Brandywine Park from the north on the northwest side of the Washington Memorial Bridge. This structure was also known as the pavilion entrance to the Brandywine Zoo. The pavilion was demolished in 1954. (Courtesy of the University of Delaware Special Collections.)

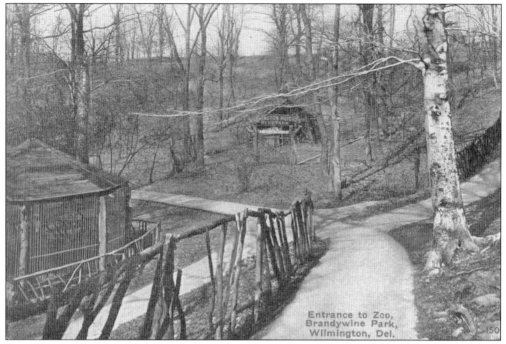

Entrance to Zoo,
Brandywine Park,
Wilmington, Del.

During the Victorian era the element of rustic architecture was used in Wilmington Park structures. By rustic is meant the use of natural-looking branches or twigs as the basic building material. The buildings in the Wilmington Zoo continued to include rustic elements, years after Queen Victoria died. The entrance to the zoo from the pavilion, seen in this view, shows a structure, possibly the Deer House built in 1904, extensively decorated with twigs and branches. In 1905 the Animal House was of rustic design and the wolf cage construction planned to use rough yellow locust logs. By 1911 the rustic look in park buildings in Brandywine Park disappeared and masonry piers and shingled roofs became the norm.

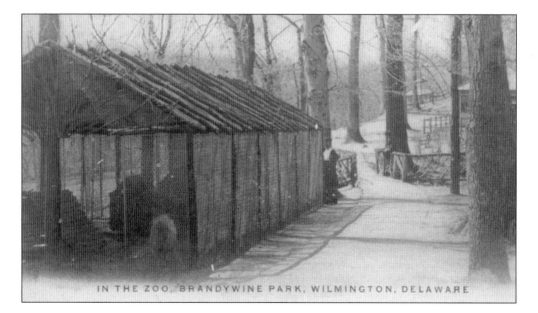

IN THE ZOO, BRANDYWINE PARK, WILMINGTON, DELAWARE

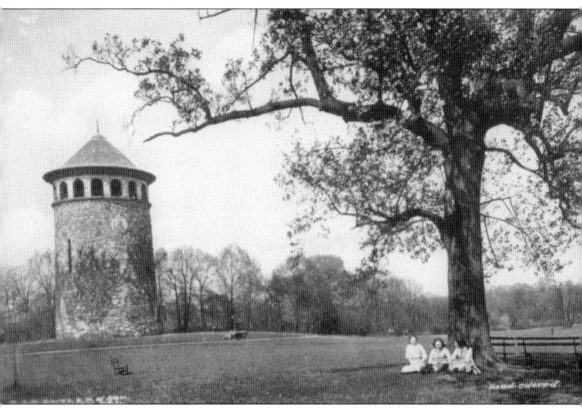

The Kentmere Parkway connected Rockford Park to Brandywine Park by 1895. The Parkway was designed by Frederick Law Olmsted, a landscape designer, who gave the Wilmington Park planners encouragement for their park system. In 1886 the city accepted the offer of land for Brandywine Park from William P. Bancroft, and in 1889, the city willingly accepted Bancroft's offer of 59 acres for Rockford Park. The du Pont family donated land facing its Experimental Station stipulating that no public structures would be built on it. By 1900 the park contained 71 of the current 104 acres making up Rockford Park. Rockford Park is known for Rockford Tower, the city's most recognizable landmark. The tower was built in 1901 to provide water to the residential neighborhood growing around it. (Courtesy of the Hagley Museum and Library.)

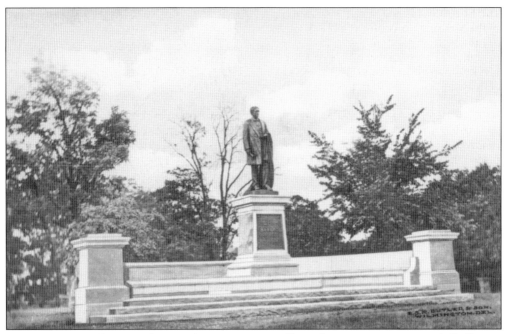

On Kentmere Parkway at the circular Drive at Woodlawn between Lovering and Shallcross Avenues stands a memorial to Wilmington's United States Senator Thomas F. Bayard. Mr. Bayard, a lawyer, was elected as a Democrat to the U.S. Senate in 1869 and served until 1885. Mr. Bayard fully supported the effort for a public park system in Wilmington and it is very fitting that his statue sits at the edge of Rockford Park. (Courtesy of the Hagley Museum and Library.)

A memorial bench to William M. Canby sits at the edge of Rockford Park overlooking Henry Clay Village and the Experimental Station. Mr. Canby, a member of a family long involved in civic affairs, was president of the Wilmington Savings Fund Society and a city councilman at the time the Wilmington Park Commissioners needed his support for the public park system. He gave them his vote and for this he is remembered at a beautiful spot in Rockford Park. (Courtesy of the Historical Society of Delaware.)

The Bringhurst Fountain is the oldest of the Wilmington Fountain Society's fountains in Brandywine Park. The Bringhurst Fountain dates back to 1872 and originally stood where Delaware and Pennsylvania Avenues meet as a memorial to the society's founder and first president, Ferris Bringhurst, who was killed in an accident in 1871. The fountain was removed from this site in 1965 and was placed in Brandywine Park's Rose Garden in 1988.

Bringhurst Fountain, Wilmington, Del.

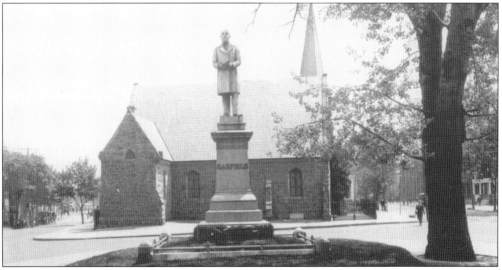

The statue of James A. Garfield, the United States President in 1880, stood to the side of the Swedenborgian Church at Eleventh and Washington Streets. Garfield was shot in July 1881 and died on September 19, 1881. The statue dedicated to his honor was moved along with the church when Pierre S. du Pont had Delaware Avenue widened in 1916. The Garfield statue now resides at Twenty-third and Jefferson Streets. (Courtesy of the Hagley Museum and Library.)

Leisure activities in Wilmington of the 1890s grew as more people had time and money for entertainment. An important source for that entertainment was the amusement park, with lakes for rowing and swimming, bandstands, live shows, movies, puppet shows, and of course, dance halls and rides. Wilmington had three amusement parks, referred to as "pleasure gardens." They were Brandywine Springs Park, Shellpot Park, and Gordon Heights Park. Rival trolley lines developed Brandywine Springs Park and Shellpot Park in the 1890s. Brandywine Springs became more popular than Shellpot Park, even with its beautiful lake, and so Shellpot closed.

The Todd Memorial stands as a memorial to the soldiers and sailors who gave their lives during World War I. The memorial stands on a triangle of land at Eighteenth and Washington Streets. William H. Todd built the memorial on the edge of Wilmington's new development, Washington Heights, in 1925 in tribute to his parents.

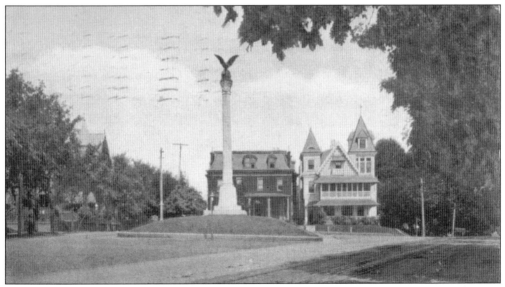

Another war memorial to the soldiers and sailors who died in all wars is located on a triangle of land at Broom Street and Delaware Avenue. The sculpture at the top of the column depicts an eagle killing a serpent. The monument was dedicated May 30, 1872, by General O.O. Howard, the director of the Freedman's Bureau, a federal agency that assisted freed slaves. Howard High School is named after him. Every Memorial Day there is a parade up Delaware Avenue to the monument and a ceremony is held. (Courtesy of the Hagley Museum and Library.)

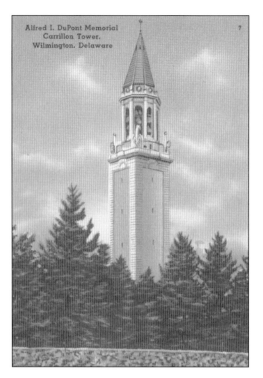

The Carillon Tower on the Alfred I. du Pont estate, Nemours, at Rockland Road and Route 141 was built in 1935 by Alfred I. du Pont as a memorial to his parents, E.I du Pont and Charlotte S. Henderson. The Alfred I. du Pont estate is the site of a specialty hospital for children built after Mr. du Pont's death in April 1935.

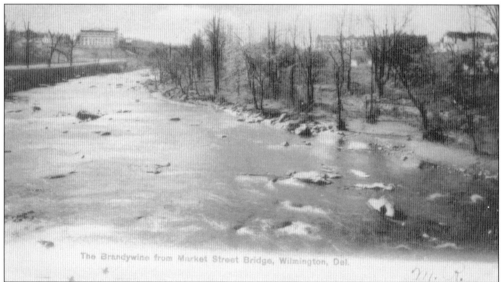

The Brandywine from Market Street Bridge, Wilmington, Del.

This idealistic view of Wilmington looking up the Brandywine River towards the Washington School on the south bank with residences on the north gives a peaceful, settled view of the area. Wilmington's parklands certainly gave that quality of life to all of those who roamed through the pathways and under the trees. This view is deceiving because Wilmington has been a city of amazing energy and much industry from the landing of the Swedes in 1654 to the building of military ships at the Harlan & Hollingsworth Plant in World War II. Wilmington, as seen through postcards, is a unique place. (Courtesy of the Historical Society of Delaware.)

BIBLIOGRAPHY

Conrad, Henry C. *History of the State of Delaware from the Earliest Settlements to the Year 1917*. 3 volumes. Wilmington, Delaware: 1908.

Cooper, Constance J. *Rockford Tower*. Wilmington, Delaware: The Cedar Tree Press, Inc., 1990.

Cooper, Constance J. *To Market, To Market*. Wilmington, Delaware: The Cedar Tress Press, 1992.

Delaware: An Inventory of the Historic Engineering and Industrial Sites. Washington, D.C.: United States Department of the Interior, 1975.

Friends of Wilmington Parks newsletters. Various articles by Susan Mulchahey Chase from 1997–1999.

Hoffecker, Carol E. *Corporate Capital*. Philadelphia: Temple University Press, 1983.

Hoffecker, Carol E. *Wilmington: A Pictorial History*. Norfolk, Virginia: Donning Company Publishers, 1982.

Hoffecker, Carol E. *Wilmington, Delaware: Portrait of an Industrial City, 1830–1910*. Virginia: University Press of Virginia for the Eleutherian Mills-Hagley Foundation, 1974.

McKelvey, Frank J. and Bruce E. Seeley. *Industrial Archeology of Wilmington, Delaware and Vicinity: Site guide for the 6th Annual Conference of the Society for Industrial Archeology*. Wilmington, Delaware: 1977.

McNinch, Marjorie G. *Bridges*. Wilmington, Delaware: The Cedar Tree Press, 1995.

McNinch, Marjorie G. "The Changing Face of Rodney Square." *Delaware History*, Volume 21, Spring-Summer 1985. Wilmington, Delaware: Historical Society of Delaware, 1985.

McNinch, Marjorie G. *Festivals*. Wilmington, Delaware: The Cedar Tree Press, 1996.

McNinch, Marjorie G. *Silver Screen*. Wilmington, Delaware: The Cedar Tree Press, 1997.

Miller, William J. Jr. *Crossing the Delaware: The Story of the Delaware Memorial Bridge*. Wilmington, Delaware: Delapeake Publishing Company, 1983.

Reed, H. Clay, ed. *Delaware: A History of the First State*. 2 volumes. New York: Lewis Historical Publishing Company, Inc., 1947.

Rendle, Ellen. *P.S. We Love You*. Wilmington, Delaware: The Cedar Tree Press, 1993.

Rendle, Ellen. *The Ghosts of Market Street.* Wilmington, Delaware: The Cedar Tree Press, 1998.

Scharf, J. Thomas. *History of Delaware, 1609–1888.* 2 volumes. Philadelphia, PA: L.J. Richards & Co., 1888.

Thompson, Priscilla M. and Sally O'Byrne . *Wilmington's Waterfront.* Images of America Series. Charleston, South Carolina: Arcadia Publishing, 1999.

Williams, William Henry. *The First State, An Illustrated History of Delaware.* Northridge, California, 1985.

Zebley, Frank R. *The Churches of Delaware.* Wilmington, Delaware: Frank R. Zebley, 1947.

PRIMARY SOURCES

DuPont Company Public Affairs Collection, Accession 1410 Box 39, Hagley Museum and Library.

The Papers of Francis Gurney du Pont, Accession 504 Box 32, Hagley Museum and Library.

The Papers of Henry Belin du Pont, Accession 1608 Box 141, Hagley Museum and Library.

The Papers of John McShain, Accession 2000 Box 30, Hagley Museum and Library.